PAPER AIRPLANES

The Collections of Harry Smith
Catalogue Raisonné, Volume I

Editors:
John Klacsmann
Andrew Lampert

 J&L Books and Anthology Film Archives

The Collections of Harry Smith, Catalogue Raisonné series, forthcoming volumes:

Beggar Signs
Books
Commercial Toys (circa 1940–1990)
Decorated Ukrainian Eggs
Gourds
Papier-mâché Masks
Realia
Records
Seminole Textiles
Tarot Cards

Also available:
String Figures (Volume II)

―――――――――――――――

Design by Jason Fulford
Photographs of Paper Airplanes by Jason Fulford

p. 12: Still from *Film Number 7: Color Study*
Preserved by Anthology Film Archives, © Anthology Film Archives

p. 236: Photograph by Robert Frank, 1994, NYC
Courtesy of and © Robert Frank

Front cover flap: *Harry Smith's eyeglasses*
Photograph by Jason Fulford

Back cover: Portrait of Harry Smith, Circa 1972, photographer unknown
From the collection Anthology Film Archives

Back cover flap: *Harry Smith's ashes*
Photograph by Andrew Lampert

Paper Airplane photographs and this edition © 2015 J&L Books and
Anthology Film Archives

ISBN 978-0-9895311-3-9
Printed in South Korea

www.JandLbooks.org
www.anthologyfilmarchives.org

CONTENTS

ACKNOWLEDGEMENTS

This book would be nothing more than a pipe dream without the incredible cooperation, information, material, and support provided by the following friends and colleagues:

Robert Haller, John Mhiripiri, and Erik Piil at Anthology Film Archives; Rani Singh at the Harry Smith Archives; Harvey Bialy, Ken Blackburn, William Breeze, Ayumi Chan, John Cohen, John Collins, Emily Davis, Walter Forsberg, Raymond Foye, Robert Frank, M. Henry Jones, Jun Kuromiya, Bryan Leitgeb, Dave Mackey, Kirt Markle, Jonas Mekas, Rosebud Feliu-Pettet, Jeff Place, Ralph Rinzler, Julie Schumacher Grubbs, Anthony Seeger, Philip Smith, and John Zorn.

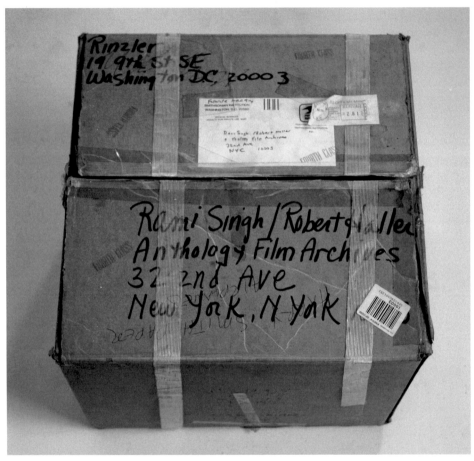

Shipping box containing Harry Smith's paper airplanes sent from the Smithsonian Center for Folk-life and Cultural Studies to Anthology Film Archives in 1994

INTRODUCTION

Mary Hill: What do you consider your truest vocation, painting or anthropology or what?

Harry Smith: Well, naturally, of the two I consider my truest vocation to be anthropology; I mean, my painting is a mere adjunct to that. This is the thing I am most interested in, linguistics and archeology, and so forth. But they are mere amusements, my true vocation is preparation for death; for that day I'll lie on my bed and see my life go before my eyes.[1]

Harry Everett Smith (1923–1991) took impish delight in rerouting inquiries and introducing new confusions into his already murky personal record with every interview he granted. A wizard and a wise-ass whose erudite monologues and sardonic commentary careened from one esoteric sphere to another, Smith's fanciful explanations about his work leave the impression of someone who was both a relentless hoaxster and an untethered genius. A charming yet cantankerous pauper in life, in death he has become nothing less than a subterranean superstar. His myriad accomplishments as a filmmaker, artist, musicologist, anthropologist, and occultist are celebrated by a range of disparate communities, most of which are invested in him for entirely different reasons. Since his death, a slew of retrospective music releases, film preservations, books, screenings, and gallery exhibitions have firmly established him as a key figure of the 20th-century American underground. While Smith's entire body of work is incomparable and justly celebrated, he is in many ways equally infamous for the many abandoned and abolished projects left in his wake, including those that were lost thanks to unpaid bills, irate landlords, numerous moves, bad moods, and self-destructive outbursts.

An experimental filmmaking pioneer whose miniature and epic masterpieces still bewilder audiences today, Smith is revered for classic works like *Film Numbers 1–5, 7, 10: Early Abstractions* (1946–57); *Film Number 12: Heaven And Earth Magic Feature*

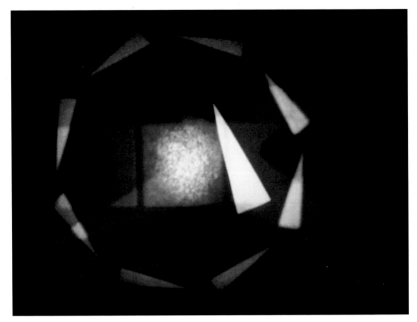

Still from Film Number 7: Color Study *(1952)*

(1957–62); *Film Number 14: Late Superimpositions* (1964); and *Film Number 18: Mahagonny* (1970–80). Critic, filmmaker, Anthology Film Archives co-founder, and longtime Smith-supporter, Jonas Mekas, proclaimed in his influential *Village Voice* column:

> There are more levels in Harry Smith's work than in any other animator I know. Animated cinema—all those Czechs, Poles, and Yugoslavs, and Pintoffs, Bosutstovs, and Hubleys are nothing but makers of cute cartoons. Harry Smith is the only serious film animator working in cinema today.[2]

Created with borrowed cameras (which he would regularly pawn) on 16mm and 35mm film between the 1940s through 1980s, the 23 multi-layered films that Smith produced are complex and rigorous, completely fluid, and spiritually charged. Often produced in poverty and solitude, the movies were made using any variety of methods including painting directly onto celluloid; single frame animating cut-out figures and other materials (such as sand and illicit drugs);

superimposing two discrete images to create a unified third; and constructing conceptual, unruly "expanded cinema" multi-projection spectaculars. Each and every work is chock full of enigmatic symbols that can be interpreted for their overarching allegorical, alchemical, and associative meanings. At the same time they can be easily enjoyed for their madcap inventiveness and aesthetic singularity. The films continue to be staples in cinematheques, classrooms, festivals, and museums around the globe.

Even though Smith's films are canonical within the history of avant-garde cinema, his greatest above-ground acclaim is for his creation of the landmark *Anthology of American Folk Music*, a triple album, six-LP set issued by Folkways Records in 1952.[3] Instead of focusing on field recordings as might be expected given such an authoritative title, the *Anthology* was a critical act of musicology wholly unlike anything that had preceded it. A serious record collector in the years before it was a certified hobby, Smith mined his exhaustive holdings of pre-World War II 78rpm discs to curate a thematically organized—yet downright indefinable— compilation of commercial recordings released between 1927 and 1932. Urban and rural, religious and irreverent, once popular but long forgotten, the set features a diverse mélange of music that all illustrate the agitated melting pot that was America up through the early 20th-century. Smith's quirky liner notes incorporate arcane images from old books and record sleeves, photos of musicians, an alphabetical index, and mystical quotes from the likes of Robert Fludd and Aleister Crowley. Reissued on CD to major acclaim (and two Grammy Awards) by Smithsonian Folkways in 1997, the *Anthology* undeniably instigated the folk music book of the 1950s and 1960s and remains revelatory to this day.

Of all Smith's near-mythic endeavors, perhaps the most wondrous and wondered about are the vast array of curious objects he accumulated over many decades. He was an inveterate collector whose possessions were as unusual and encyclopedic as his creative and scholarly pursuits. From Ukrainian painted eggs and Seminole textiles to string figures and tarot cards, Smith amassed a sweeping assortment of folk relics and trinkets that profoundly informed his films, paintings, drawings, and anthropological studies. *The Collections of Harry Smith, Catalogue Raisonné* series is an attempt

to provide greater insight into these significant objects which, up until now, have been more rumored about than seen. Beyond what Smith lost in his own lifetime, the sheer quantity, dispersion, and fragility of his surviving collections make them difficult to grasp, much less display. Surveying the dynamic range of things he gathered and the vast terrain of subjects that he probed allows us to better parse out the connective threads that underscore his multiple personas and eclectic activities.

Smith's preoccupation with music and anthropology, as well as his fervor for collecting, all date back to his early years in the Pacific Northwest. His father worked for the Pacific American Fishcrics, Inc. and his mother taught on a Lummi Indian Nation reservation. They were practicing Theosophists whose engagement with spirituality, occultism, and alchemy was passed onto their son. It was likely these familial esoteric studies that helped spark Smith's interests in systems and interconnectivity. As a teenager, Smith spent a significant amount of time on different reservations documenting music, rituals, and dialects. He made field recordings, took photographs, and devised his own systems of transcription, a practice that would later cross over into his painting and "visual music" style of filmmaking. Smith possessed a precocious proclivity for anthropology, and it was also around this time that he began collecting Native American cultural artifacts, folk art, toys, albums, and objects. In a 1968, interview Smith once expressed, "All my projects are only attempts to build up a series of objects that allow some sort of generalizations to be made regarding popularity of visual or auditory themes."[4] Amassing objects, samples, data, and information was a daily form of continual cross-referencing research that dominated much of Smith's time, space, and resources.

Following high school, Smith briefly studied anthropology at the University of Washington before moving to the San Francisco Bay Area in 1945 (he claimed the move was inspired by the first puff of marijuana he ever inhaled during an earlier visit). There, he aided Paul Radin, an anthropologist at the University of California, Berkeley, whose work in linguistics to find unity between numerous North America languages and folklore left a big impression on Smith. It was in Northern California that he became deeply embroiled in the cinema, art, jazz, and drug cultures that infused

his ongoing intellectual, spiritual, and creative efforts. Smith's exceptional geometric abstract paintings and early ecstatic films captured the attention of Hilla Rebay, director of the Museum of Non-Objective Painting, which is today the Guggenheim Museum. She offered financial support that precipitated Smith's relocation to New York City in 1951.

In preparation for his cross-country move Smith "shipped all my stuff collect and—however, in various batches. Most of it I lost because—I mean my most valuable belongings, you know, my collection of large-size Kwakiutl and Swinomish ceremonial paraphernalia. The large things, like house—entire houseposts and stuff I gave to the museum at the University of Washington."[5] This revealing statement summarizes a recurrent trend that would befall many of the collections he accumulated over time. Smith's obsessive assembling of things—whether they be books and records or string figures and gourds—was only matched by his habit of misplacing, throwing out, or hastily giving things away. For most of Smith's adulthood he lived in cramped hotel rooms that also served as art studios and storehouses for his ever-growing archives. Personal recollections, photos, and footage all reveal a frail, frequently inebriated man living amongst towering boxes and over-stuffed shelves, every square foot jammed with yet another of his comprehensive assortment of wonders. Regarding his substantial collecting tendencies, Smith explained:

> I'm leaving it to the future to figure out the exact purpose of having all these rotten eggs, the blankets, the Seminole patchwork I never look at, and records I never listen to. However, it's as justifiable as anything that can be done, as any other type of research, and is probably more justifiable than more violent types, like fighting with someone or becoming an export banker. It is a way of fooling away the time, harmlessly, as much as possible.[6]

* * *

All of which brings us to Smith's extraordinary collection of found paper airplanes. Key tools in the development of aviation and

aerodynamics, paper plane making is nevertheless an activity most associated with children, especially boys. The exact origins of this pastime cannot be precisely dated, but airplanes are thought to follow the invention of paper in China around AD 105, and they most certainly existed in 6th century Japan during the development of origami. But from where did Smith's intrigue arise? He rarely traveled by plane, and flight was not a particular preoccupation in any of his other works or projects. Furthermore, paper airplanes are not a topic that Smith addressed in his published writings, lectures, or interviews. A number of Smith's friends knew of his involvement with the paper planes, but few can really speak to the specifics of this attraction or when it first started. Smith's close friend William Breeze recalls:

> He and I discussed it more than once as we usually met for dinner and a trip to the Strand on Fridays (my payday in those days!) and walked the neighborhood. He found several planes and would immediately stop to fish out a pencil and make notes on it. As I recall he was interested in the changes in their morphology over the years, with some plane designs disappearing and then mysteriously reappearing years later.[7]

Supposedly handed a blacksmith's tool set by his father around age 12 and then instructed to "convert lead into gold," Smith's alchemical education and subsequent practice taught him much about the transmutable nature of materials and forms.[8] Was it the transformation of paper to plane—from trash to treasure—that compelled his collecting? The planes also strongly relate to Smith's fascination with the function of toys and games as teaching tools for communication, storytelling, and generational cultural exchange. In this way, the planes are strongly connected to his work with string figure games (see *String Figures: The Collections of Harry Smith, Catalogue Raisonné, Volume II*). Furthermore, the geometry, design, and intricate folds involved in producing paper planes readily speak to his preoccupation with process and craft. He likely admired their individuality as well as what they displayed about regional, national, and international culture at large. As with his

other collections, Smith was not necessarily looking to show that the planes were different, but rather how much they were the same, if not solely in design then in impulse.

"He was always, always, always looking for them on the street any time he could find them," says Smith's one-time protégé, M. Henry Jones, a skilled animator and inventor. "He would run out in front of the cabs to get them, you know, before they got run over. I remember one time we saw one in the air and he was just running everywhere trying to figure out where it was going to be. He was just like out of his mind, completely. He couldn't believe that he'd seen one. Someone, I guess, shot it from an upstairs building." Jones visited Smith at his room in the Chelsea Hotel in 1976 where "he had the paper airplanes. Then he disappeared for a short while...but then he wound up at the Hotel Breslin. And at the Breslin, he still had a giant pile of paper airplanes. And I even asked him because the pile was different. He said that the stuff from the Chelsea got boxed and this was his new collection."[9]

Today it is impossible to know exactly how many specimens Smith came across in his paper airplane hunt, or the fate of those he possibly misplaced. When asked about how many planes he might have located, Rosebud Feliu-Pettet, whom Harry referred to as his "spiritual wife," half-jokingly replied, "I don't know how many boxes he would've had. Multiple, I would say. Meaning more than two, less than 50."[10]

Smith's extant collection contains 251 "samples" (as he described them in a note found along with the planes). The earliest example is dated 1961, and the last comes from 1983. All of the planes were found in New York City, and nearly each one is annotated with handwritten information detailing when and where he acquired it, sometimes including such specific details as cross streets; which side of the street it was found on; the time of discovery; and other pertinent information. But his record keeping was not necessarily consistent and he had occasional slippages with dates, spelling, and proper street name citations, such as his repeated identification of Wooster Street in the SoHo neighborhood as "Woocester." Although Smith apparently did not attempt to classify and index the whole paper airplane collection, he did attempt to categorize some. A document related to the planes known as the "Cooper Union"

group (see PA14–PA32) includes rudimentary notes for a classification system that uses the letters "A", "B", and "C" to denote the number of corner folds.

Of all the planes, 20 were actually created for Smith upon request by guests to his room, and at other opportune moments. M. Henry Jones relates that:

> When someone came to his place and asked, "Oh, what are those paper airplanes?"—he would always say something like, "Can you show me the one that you did when you were a kid?" That's what he was interested in. What was the main one that you did, when you learned how to do it, and did you do a lot of them?[11]

The Cooper Union planes are likely the products of a visit to Jonas Mekas' film class at the university in March 1967. One undated example made from a photocopy of Smith's string figure notes (PA237) is marked as demonstrating a technique "Robt. Frank Learned in 1935." A close friend and great admirer of Smith, photographer Robert Frank would have been around ten at the time he first made it. When shown a photo of his plane in 2012, Frank warmly smiled and stated that he had never seen it before—he does not recall ever playing with paper airplanes as a child. Asked why his name was on it, he responded that Smith must have made it.

As would be expected, the examples found in this collection run the gamut in terms of size and construction. They are made out of everything from childrens' homework, spiral bound notebook paper, and colored construction paper to fliers, hotel stationery, receipts, telephone book pages, a menu for the nightclub Max's Kansas City (PA129), and a psychedelic handbill for a Greenwich Village concert by Dave Van Ronk, The Mothers of Invention, and Ian and Sylvia (PA45), amongst many other materials. Flattened and filed away by Smith, many of the planes are weathered and decomposing, trampled by busy New Yorkers and tourists, or run over by uncaring cars and bicyclists. The longer you look at them, the more they start to feel like abstract, anthropomorphic snapshots of their makers. Even the most basic planes have a glimmer of personality. Certain planes look ready to glide great distances; others have a truly sad

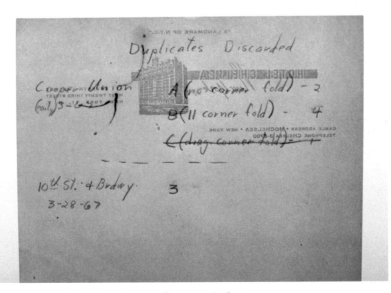

Notes by Harry Smith found among the paper airplanes

sack "Spruce Goose" quality about them. If the goal of making a paper airplane is for it to fly, then in all too many cases here we find that form clearly overrides or underserves function.

After over 20 years of plane gathering, Smith must have decided that it was time to pass them on. In his introduction to the book *American Magus: Harry Smith, A Modern Alchemist,* William Breeze commented, "By the early 80s he had no less then a dozen large boxes. The Smithsonian Air and Space Museum sent a special courier when he donated the collection."[12] Rani Singh, director of the Harry Smith Archives, seconded this claim when she wrote, "He donated the largest known paper airplane collection in the world to the Smithsonian Institute's National Air and Space Museum."[13, 14] A 2003 article in *Frieze* magazine claimed that the collection numbered five large cardboard boxes and was donated to the Air and Space Museum in 1984. The article goes on to note that the planes "disappeared" and that one box of them "turned up in the bowels of Anthology Film Archives" following Smith's death.[15]

Looking back in 2015, Breeze writes:

> I recall seeing a stack of boxes addressed to the Smithsonian at the Breslin. I was probably exaggerating in saying a dozen, but I'm sure that it was more than one. I have a pretty clear memory of them standing in the center of the room. It was a bother as they were supposed to pick them up, and they didn't come for a while, so the boxes sat there, which I think prevented Harry from setting up one of his usual card tables.
>
> I suspect that I may be responsible for starting the now oft-repeated meme about the Air and Space Museum in my foreword. Maybe I had that from Harry—he may have thought this the case, but I may also have obtusely assumed that, not realizing that the interest would come from another branch of the Smithsonian with anthropological emphasis.
>
> For what it's worth, I dredged up a memory that a messenger took the boxes to Cooper Union, as they were to go on to the Smithsonian from there. Why Cooper Union,

and who there might have been involved, I don't know, and doubt I ever did. But the memory probably has some basis in reality.[16]

It is certainly possible that Smith gifted the collection to the Smithsonian in 1984—the year is in line with the last dated plane from 1983. The planes, however, did not simply resurface from the depths of Anthology. Jonas Mekas remembers, "Harry was very unhappy that he had at some point given the Smithsonian some of his stuff. He said it just sits there in the basement in boxes. He told me that he will try to get them back."[17] The planes were never returned to Smith in his lifetime. As it turns out, the planes were not at the National Air and Space Museum, as was frequently rumored, but instead were in the possession of—or at least eventually repatriated by—the Smithsonian Center for Folklife Programs and Cultural Studies. In 1994, after a request by Rani Singh, Director of Harry Smith Archives, and Robert Haller, Director of Anthology Film Archives, a single box containing 251 paper airplanes (all pictured in this volume) was sent from the Smithsonian to Anthology. They were diligently stuffed into 11 envelopes, including interoffice memo enclosures from the Smithsonian Folklife Program, an indication that at least some had been repackaged.

The planes were mailed by Ralph Rinzler, a musician, folklorist, and founding Director of both the Office of Folklife Programs and the Festival of American Folklife. Rinzler eventually became Assistant Secretary for Public Service at the Smithsonian, but back in his 20s he had cataloged the massive 78rpm record collection that Smith sold to The New York Public Library. Smith and Rinzler probably first encountered each other at Izzy Young's Folklore Center in Greenwich Village in the early 1960s.[18] Given their association, it is plausible that the paper airplane donation was originally arranged with Rinzler, who Smith "revered."[19] Rinzler passed away in 1994, a little more than three months after he shipped the paper planes to Anthology.

Smith may very well have shipped Rinzler or another contact at the Smithsonian more boxes of planes, but if he did then their current location remains unknown. To date, no other paper planes have turned up in either the Smithsonian's Ralph Rinzler Folklife

Archives and Collections or the National Air and Space Museum. Furthermore, none of Smith's planes were ever formally accessioned into the Smithsonian's collection. So, does that mean that there are more planes gathering dust at the Smithsonian or in a box mislaid somewhere else? This remains a rhetorical question because when it comes to Harry Smith, anything is possible—or at least probable. Following their resurfacing in 1994, the reclaimed paper airplanes lived for the next 19 years alongside the originals and masters for all of Smith's surviving films, scores of field recording tapes, paintings, drawings, papers, objects, and personal items that comprise the sizable Harry Smith collection at Anthology Film Archives. In 2013, Anthology donated the paper airplanes to the Getty Research Institute in Los Angeles where they joined other collections previously transferred by the Harry Smith Archives.

In the end this is all, unsurprisingly, hard to follow. Even though it cannot explicitly be said why Smith collected his paper airplanes, it is certain that others were not looking at them—or for them—with such a calculating eye. Leading paper airplane experts Ken Blackburn, John Collins, and Dean Mackey all agree that no one else seems to have been doing such research. While there are plenty of informative how-to publications filled with paper plane designs, there are no serious academic or anthropologic studies on the subject in English. Was Smith planning to write a book on his found planes? Did he think that they had something to say or show? Maybe Rosebud summarizes it best when she points out:

You know, he was an anthropologist—everything was fodder for his mill, as it were. Hanging the microphones out of Allen Ginsberg's window just to get street sounds—it was all part of the same picture, the society at this time, in this world. All of his collections were part of this. This is what was happening, in this time frame, in this universe, in New York City.[20]

Notes

1. Harry Smith, "Harry Smith Interviewed by Mary Hill," *Film Culture*, Number 76, 1992, 2.

2. Jonas Mekas, *Movie Journal: The Rise of a New American Cinema* (New York: Macmillan, 1972), 182.

3. The *Anthology of American Folk Music* was initially issued by Folkways Records in 1952. It was reissued with different cover art by Folkways Records in 1967. In 1997, it was issued by Smithsonian Folkways as a six-CD set with reproductions of the original liner notes and new essays, appreciations, and annotations. In 2000, the long-planned fourth volume was finally issued by Revenant Records as a two-CD and three-LP set. All four volumes were reissued on vinyl by Mississippi Records in 2014 following a 2010 vinyl reissue on Doxy Records in Italy.

4. John Cohen, "A Rare Interview with Harry Smith," *Sing Out!* Volume 19, Number 2 (July/August 1969), 27. Reprinted in Rani Singh, ed., *Think of the Self Speaking: Harry Smith, Selected Interviews* (Seattle: Elbow/Cityful Press, 1998), 97.

5. Gary Kenton, "March 1983/84," *Think of the Self Speaking: Harry Smith, Selected Interviews*. Rani Singh, ed. (Seattle: Elbow/Cityful Press, 1998), 18.

6. John Cohen, "A Rare Interview with Harry Smith," *Sing Out!* Volume 19, Number 2 (July/August 1969), 27. Reprinted in Rani Singh, ed., *Think of the Self Speaking: Harry Smith, Selected Interviews* (Seattle: Elbow/Cityful Press, 1998), 97.

7. William Breeze in an email correspondence with Andrew Lampert, April 20, 2015.

8. Harry Smith, "Harry Smith Interview." Interview by P. Adams Sitney. *Film Culture*, Number 37, 1965, 5.

9. M. Henry Jones in a personal interview, March 12, 2015. Interview by John Klacsmann and Andrew Lampert.

10. Rosebud Feliu-Pettet in a personal interview, April 23, 2015. Interview by Andrew Lampert.

11. M. Henry Jones in a personal interview, March 12, 2015. Interview by John Klacsmann and Andrew Lampert.

12. Paola Igliori, ed., *American Magus Harry Smith: A Modern Alchemist* (New York: Inandout Press, 1996), 9.

13. Smith may have indeed assembled the largest collection of found paper airplanes in the world. However, John M. Collins, designer of the paper airplane that won a Guinness World Record for farthest paper aircraft distance, said in a phone call with Andrew Lampert on April 12, 2015 that the now defunct Paper Airplane Museum in Kahului, Hawaii, might have at one point held this record with over 2000 models supposedly in their collection.

14. Paola Igliori, ed., *American Magus Harry Smith: A Modern Alchemist*, 16.

15. George Pendle, "Picture Piece: Harry Smith's Paper Aeroplane Collection," *Frieze*, Issue 72, January/February 2003.

16. William Breeze in an email correspondence with Andrew Lampert, April 20 and April 22, 2015.

17. Jonas Mekas in an email correspondence with Andrew Lampert, April 7, 2015.

18. John Cohen believes that they met at Izzy Young's Folklore Center in Greenwich Village in 1961. John Cohen in a personal interview, April 22, 2015. Interview by John Klacsmann and Andrew Lampert.

19. William Breeze in an email correspondence with Andrew Lampert, April 23, 2015.

20. Rosebud Feliu-Pettet in a personal interview, April 23, 2015. Interview by Andrew Lampert.

PAPER AIRPLANES

The following photographs document the 251 extant paper airplanes collected by Harry Smith in New York City, circa 1961–1983.

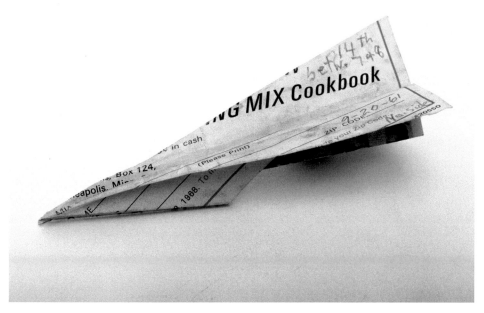

PA1

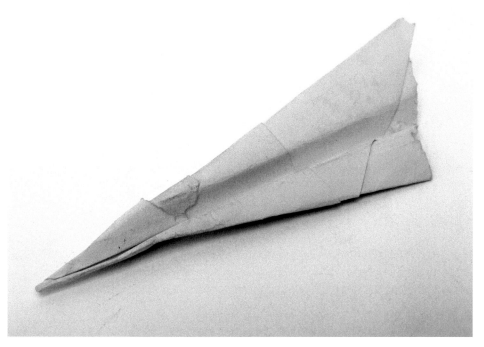

PA2

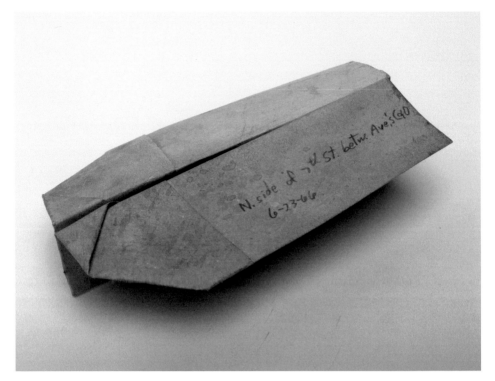

PA3

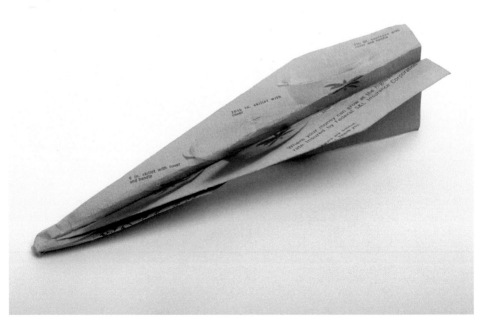

PA4

PA5

PA5a

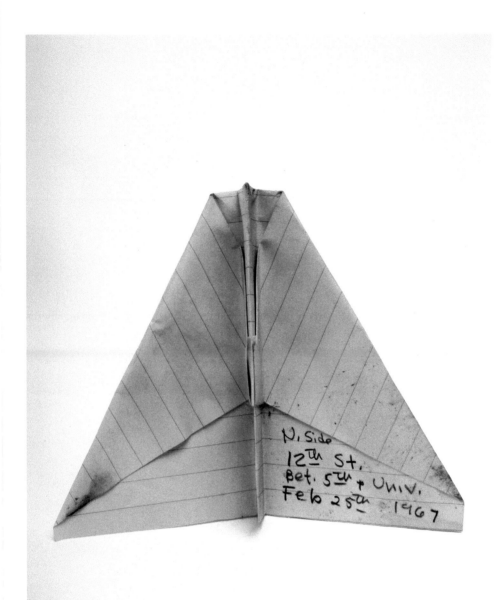

PA5b

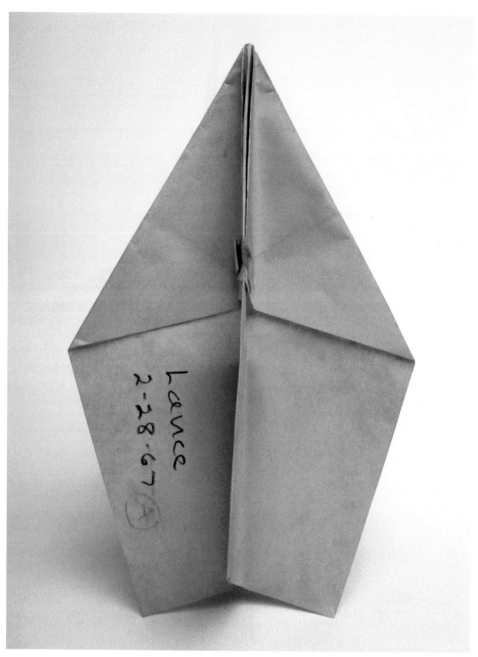

PA7

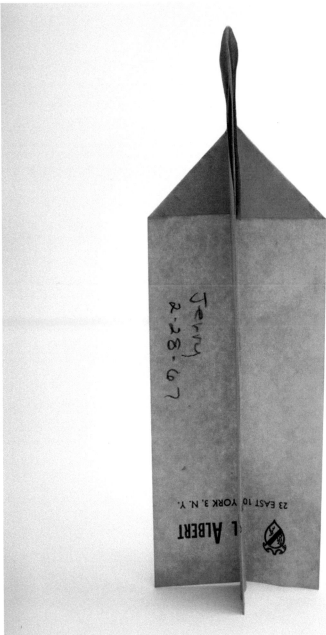

PA8

PA9

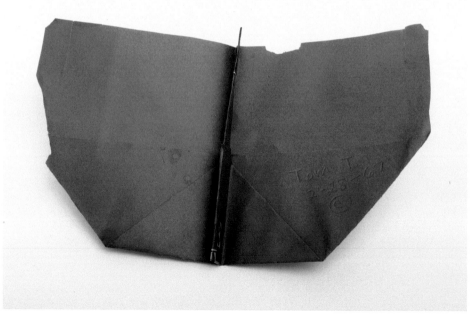

PA9a

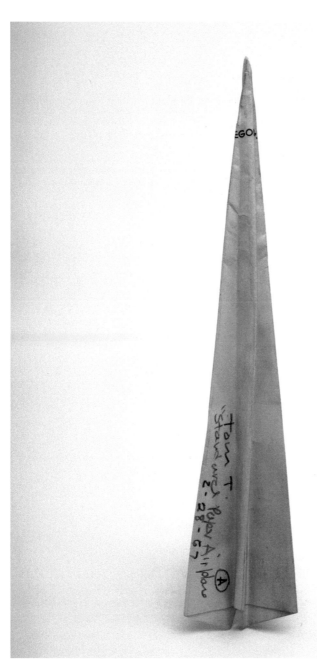

PA10

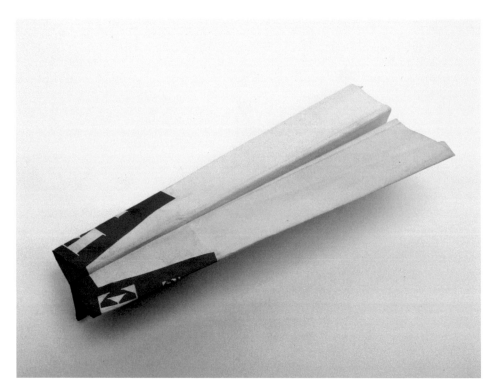

PA11

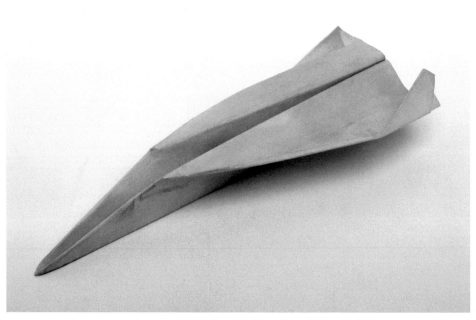

PA12

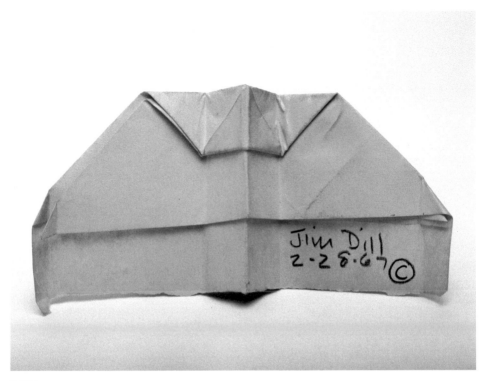

PA13

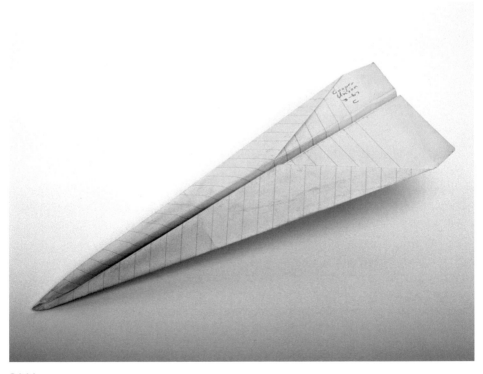

PA14

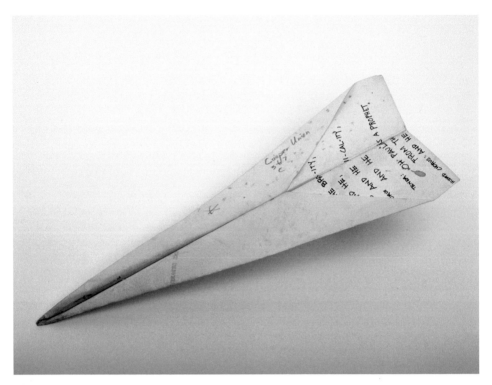

PA15

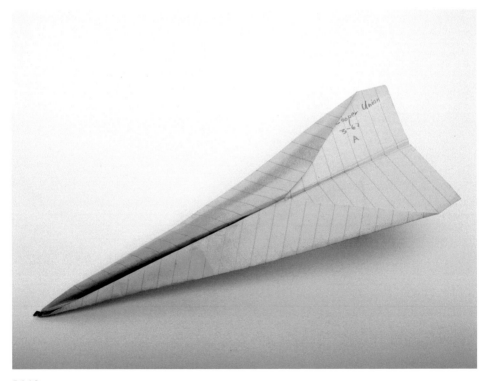

PA16

PA17

PA18

PA19

PA20

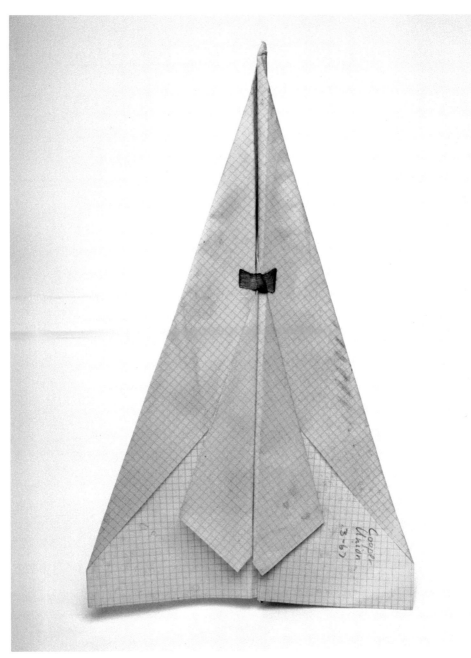

PA21

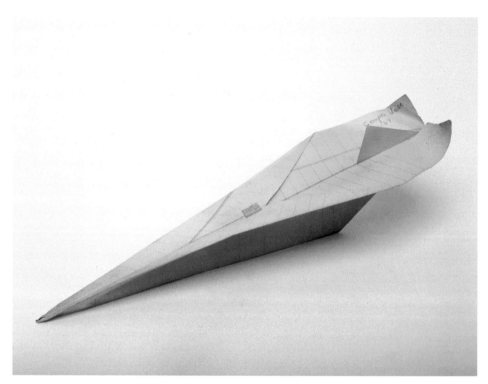

PA22

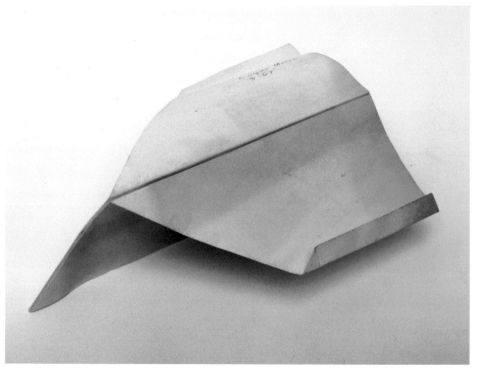

PA23

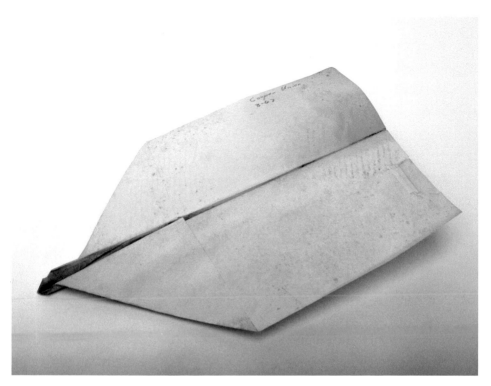

PA24

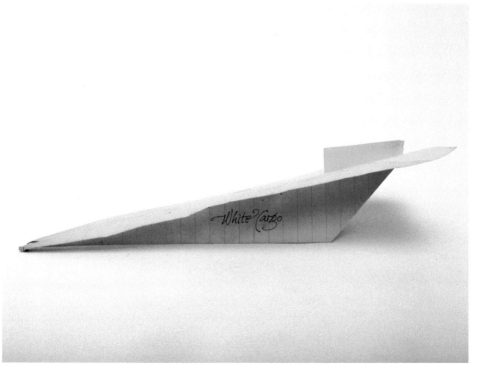

PA25

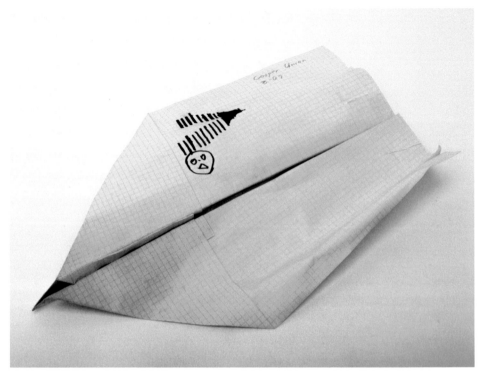

PA26

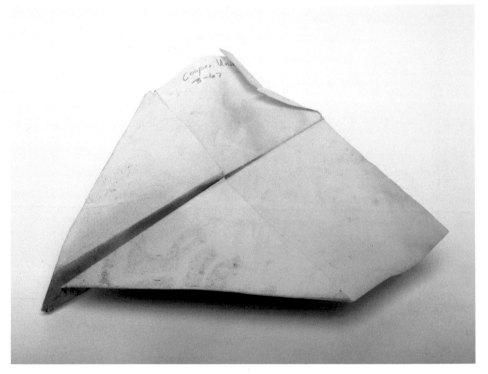

PA27

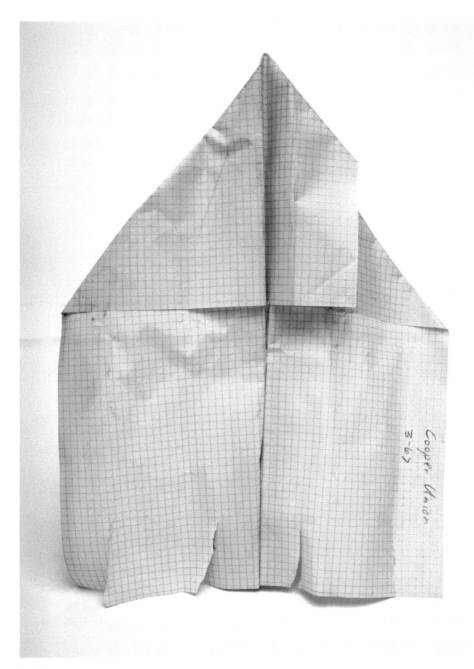

Cooper Union
3-67

PA28

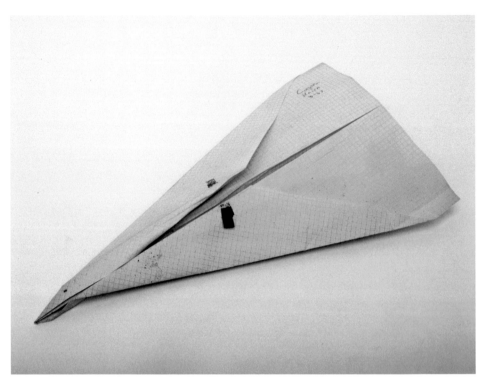

PA29

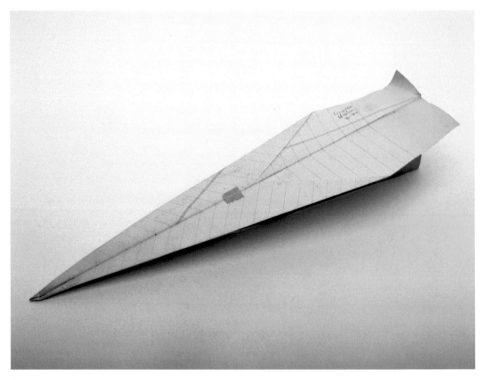

PA30

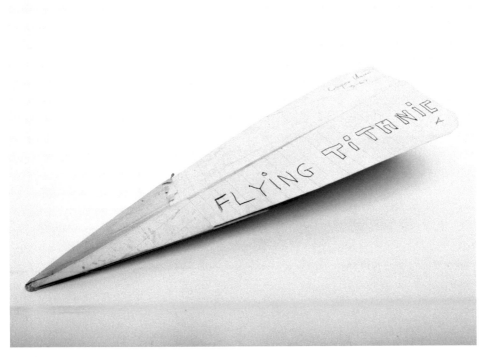

PA31

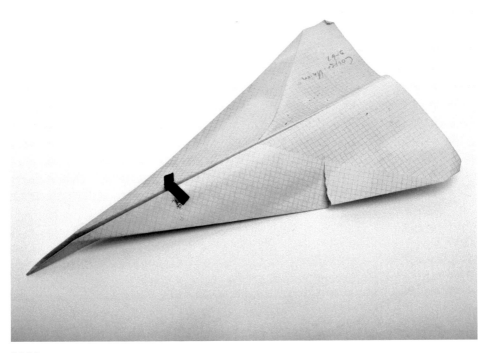

PA32

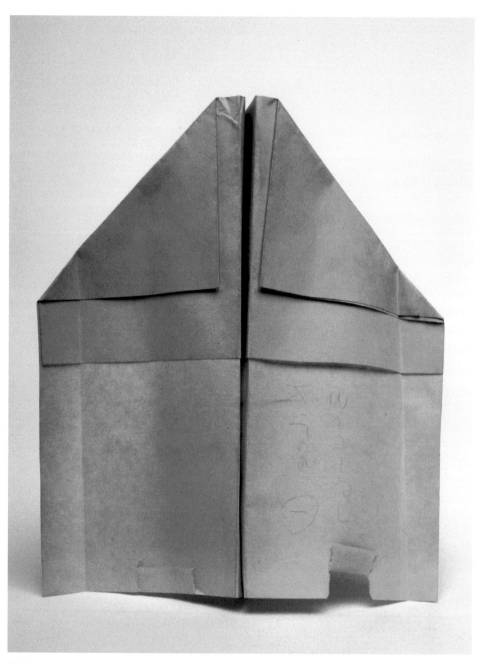

PA33

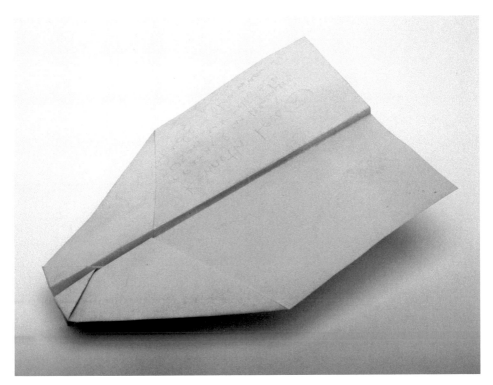

PA34

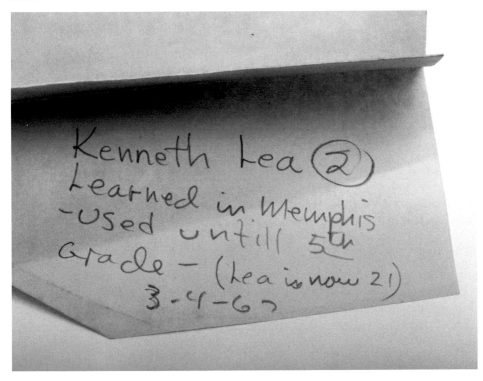

PA34a

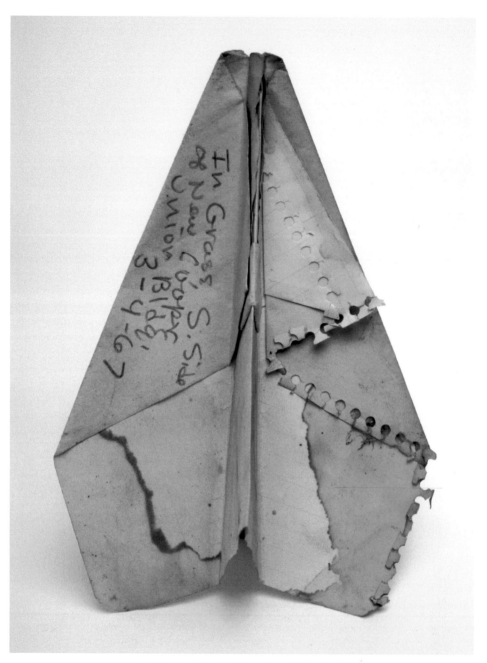

PA35

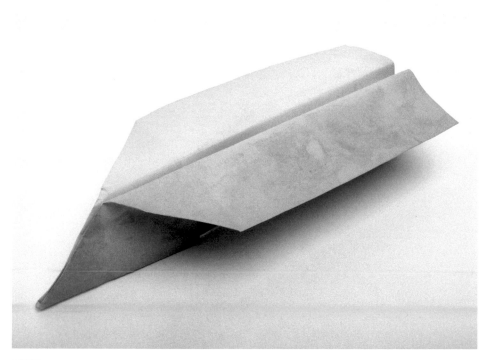

PA36

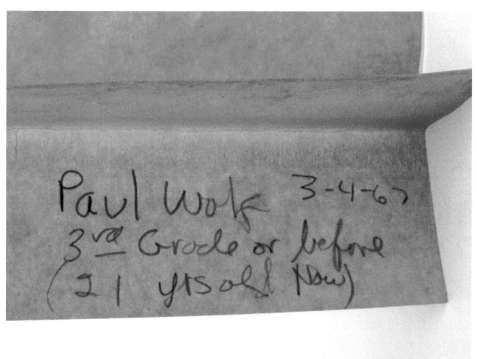

PA36a

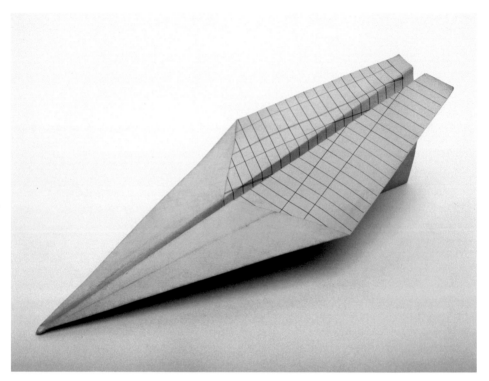

PA37

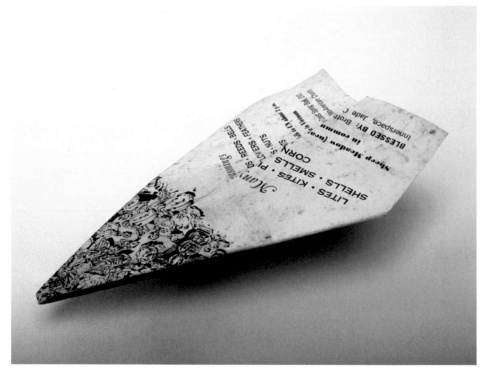

PA38

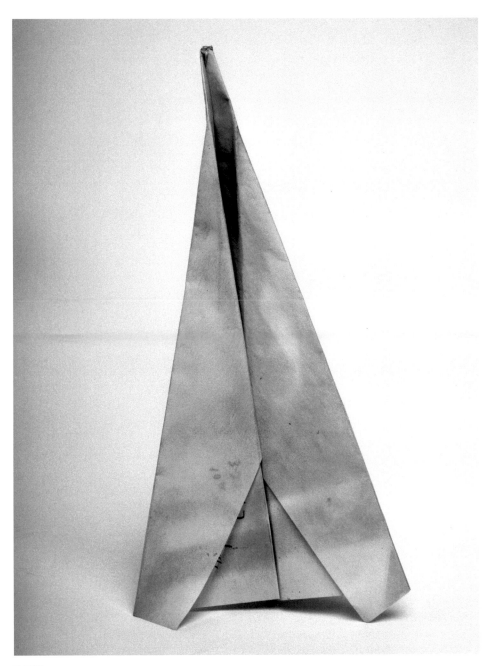

PA39

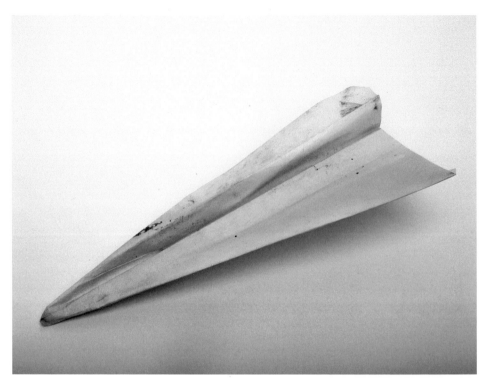

PA40

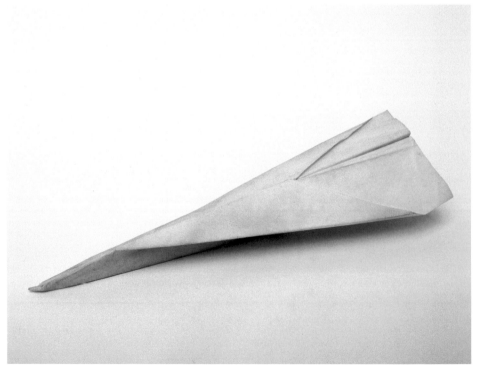

PA41

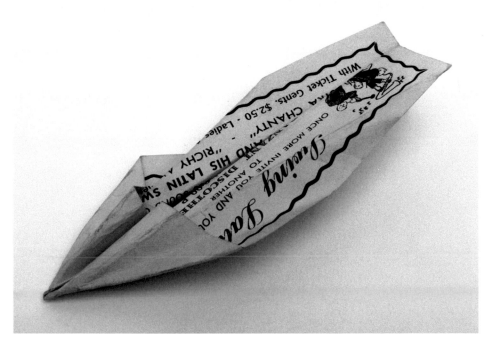

PA42

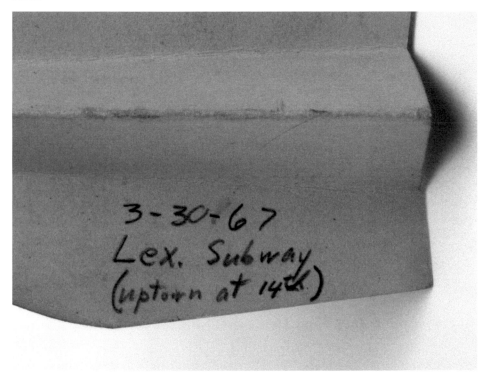

PA42a

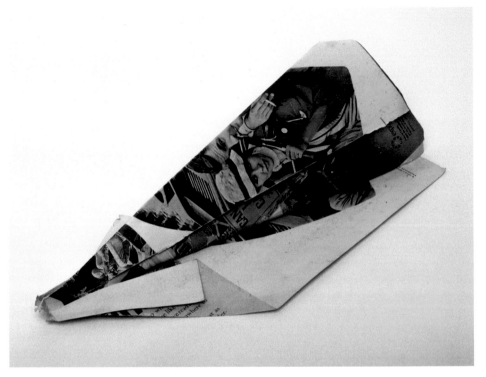

PA43

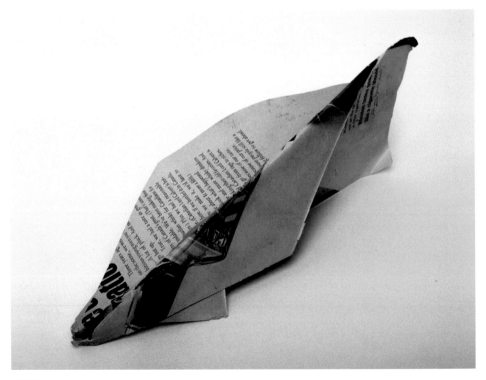

PA43a

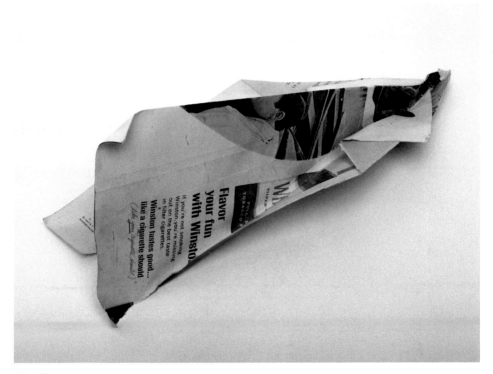

PA43b

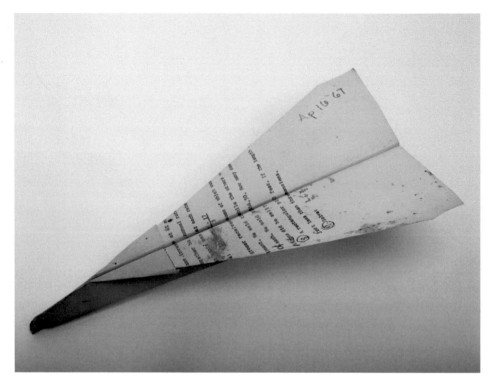

PA44

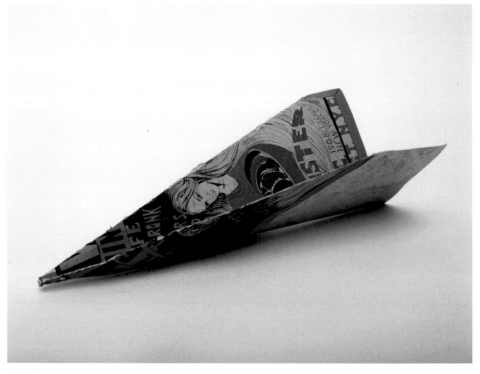

PA45

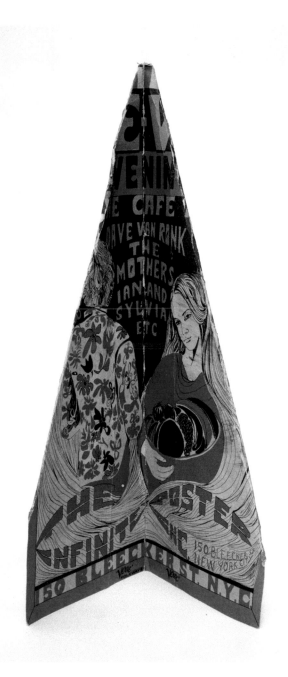

PA45a

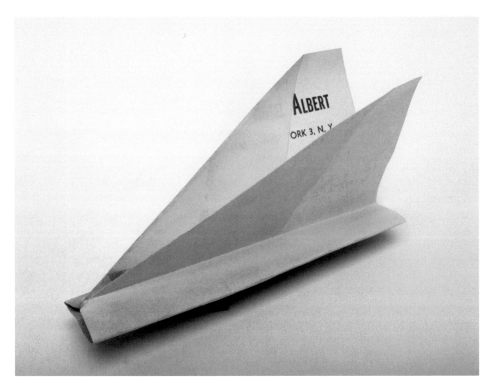

PA46

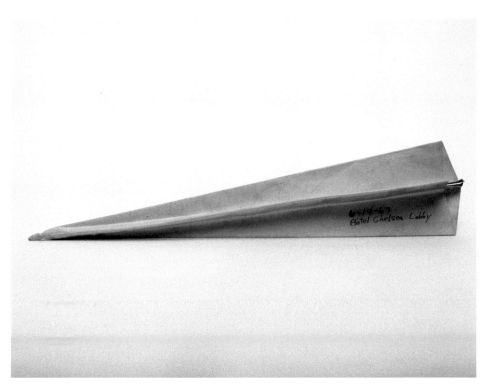

PA47

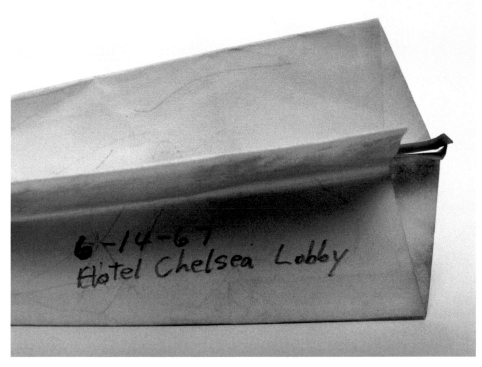

PA47a

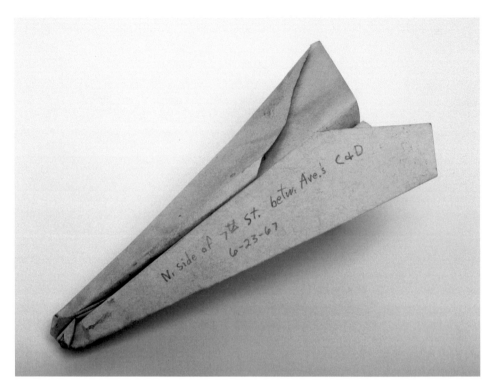

PA48

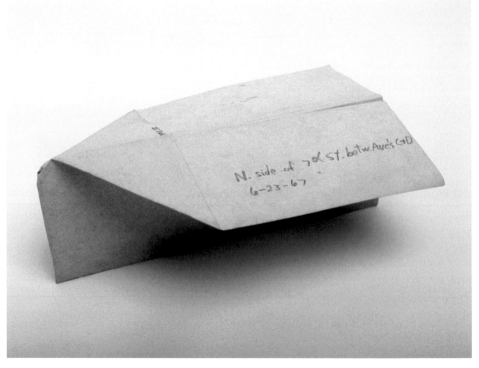

PA49

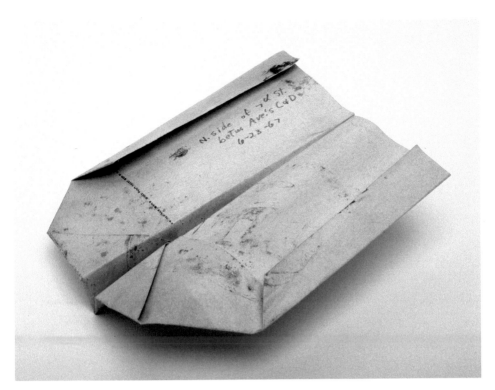

PA50

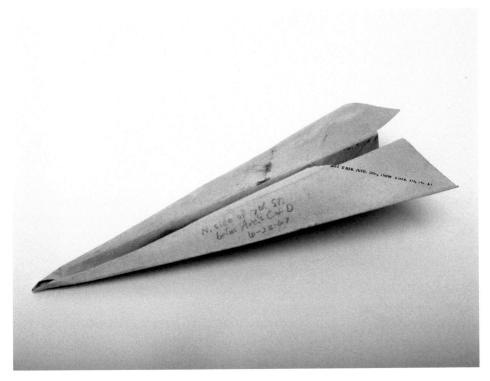

PA51

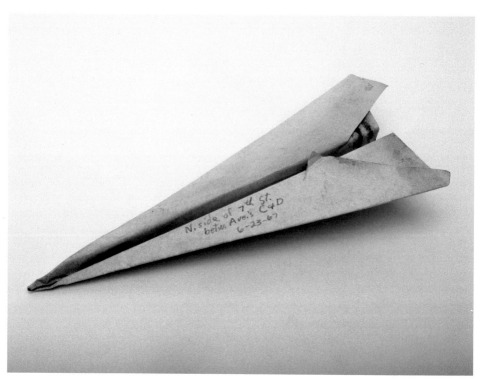

PA52

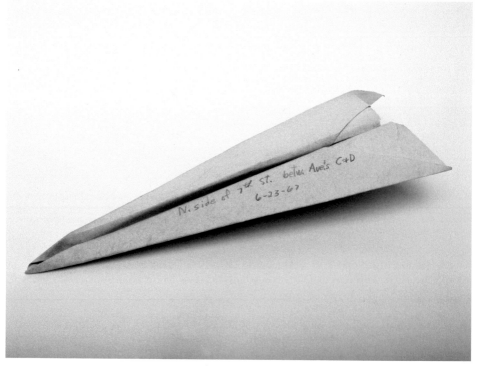

PA53

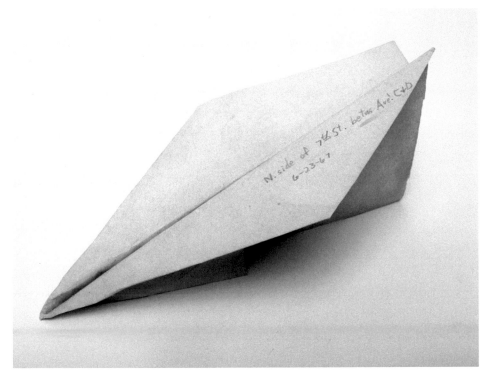

PA54

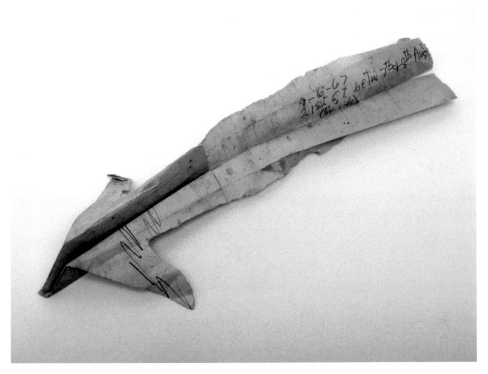

PA55

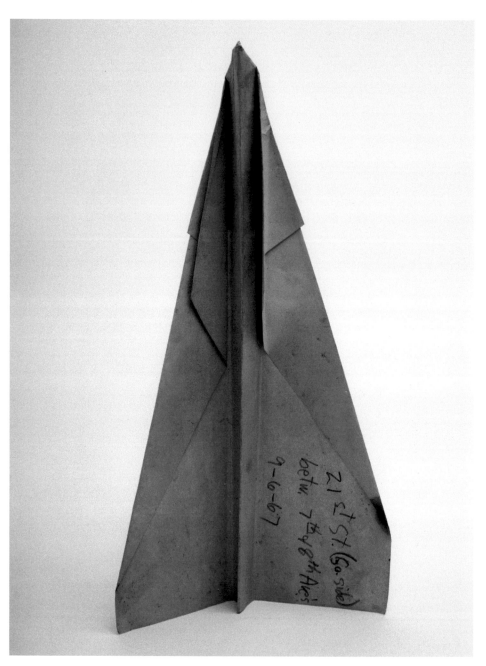

PA56

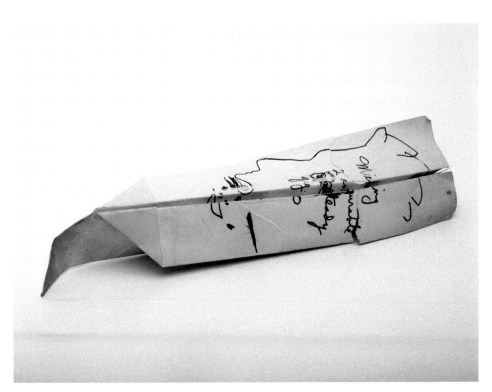

PA57

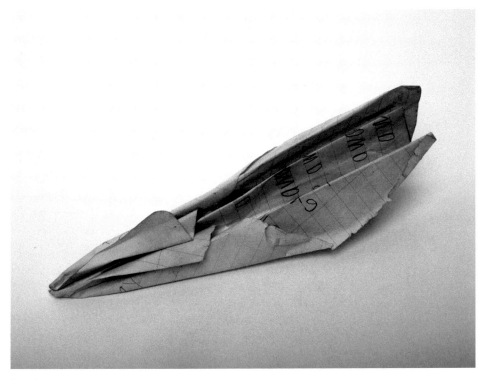

PA58

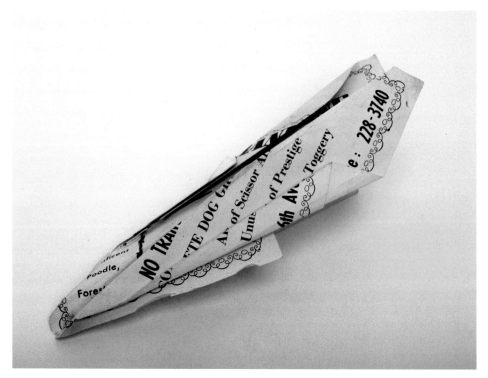

PA59

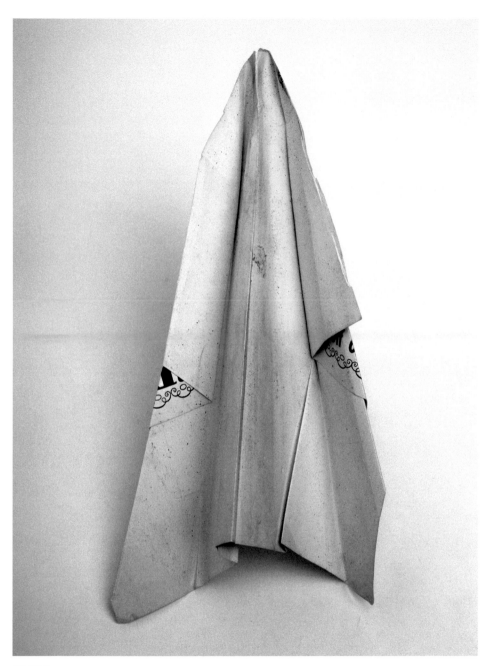

PA59a

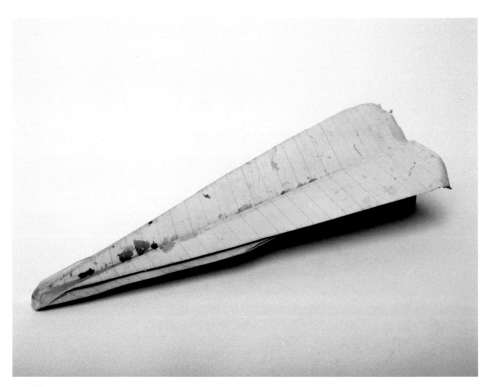

PA60

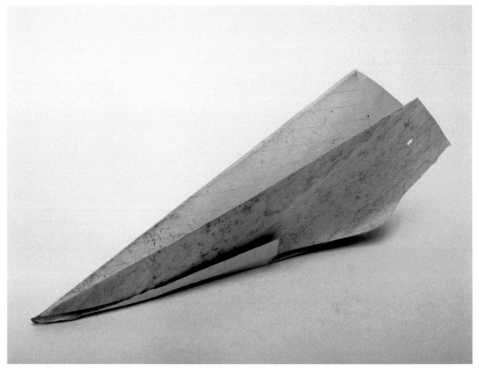

PA61

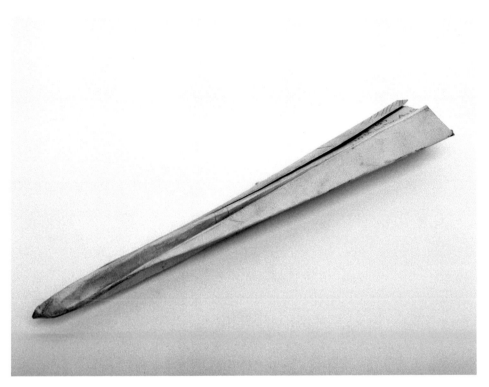

PA62

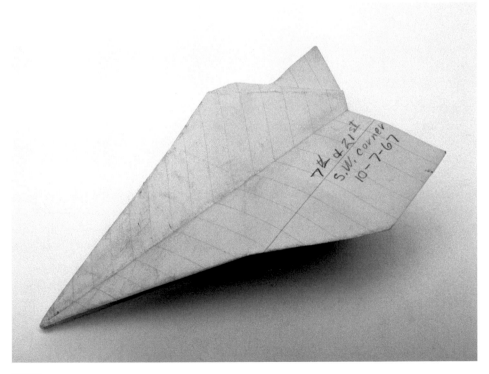

PA63

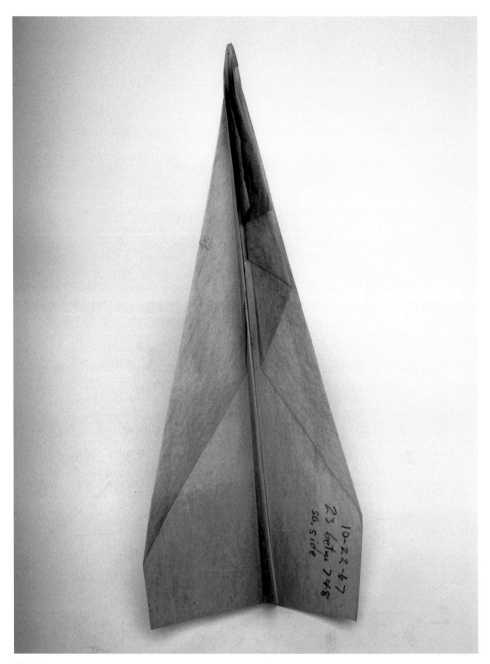

PA64

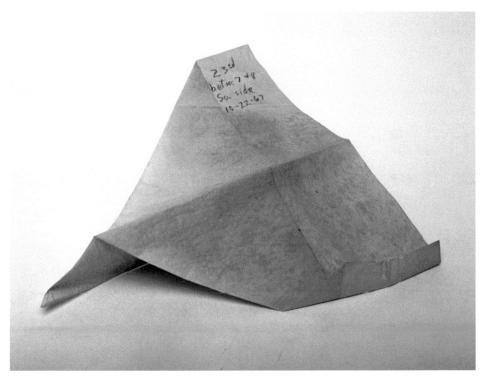

PA65

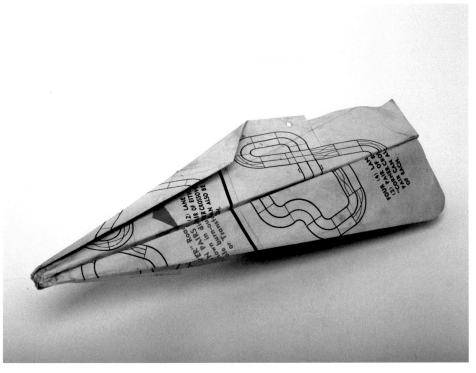

PA66

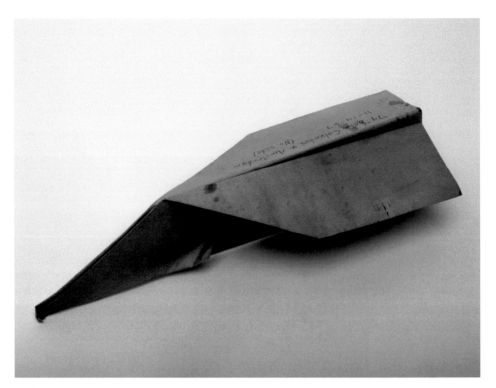

PA67

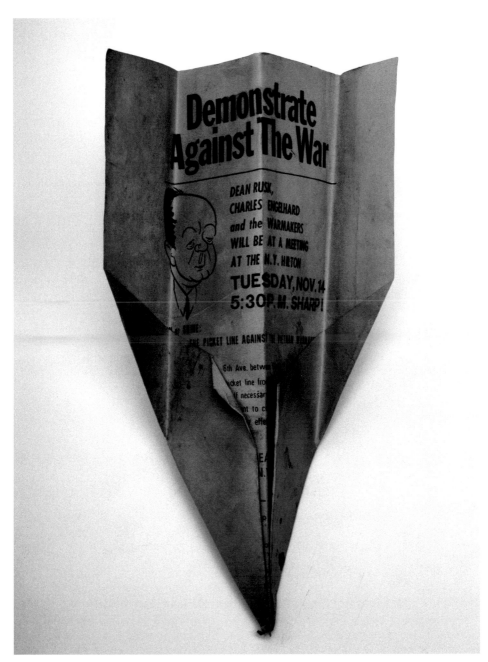

PA67a

PA68

PA69

PA70

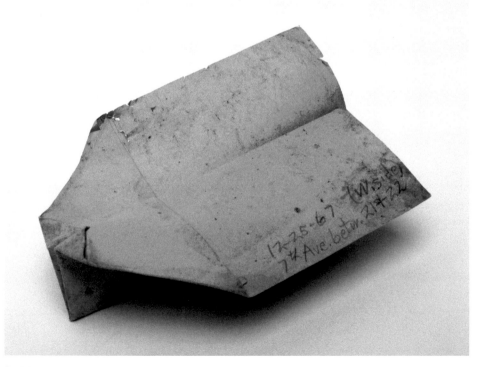

PA71

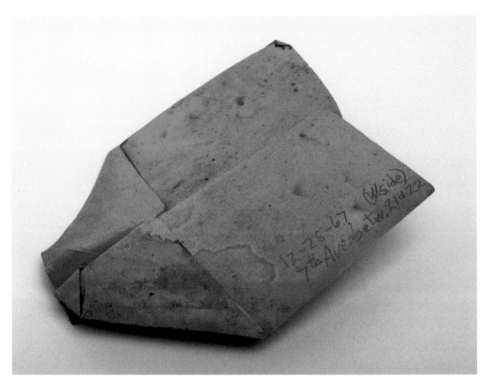

PA72

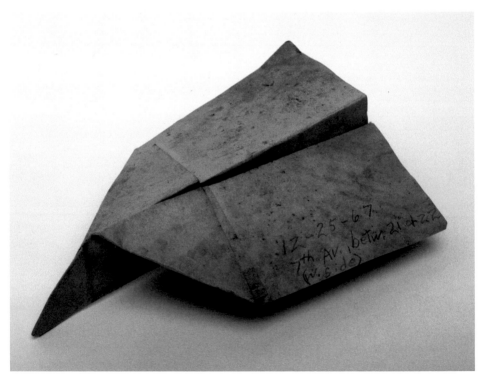

PA73

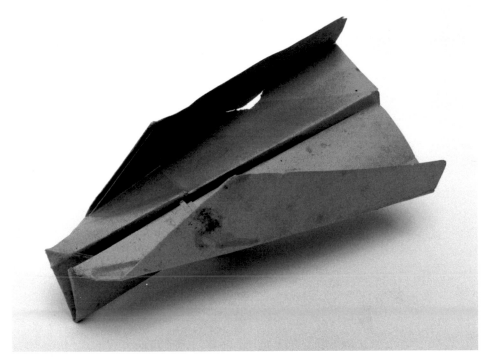

PA74

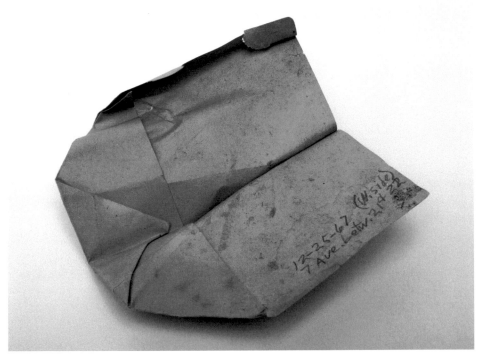

PA75

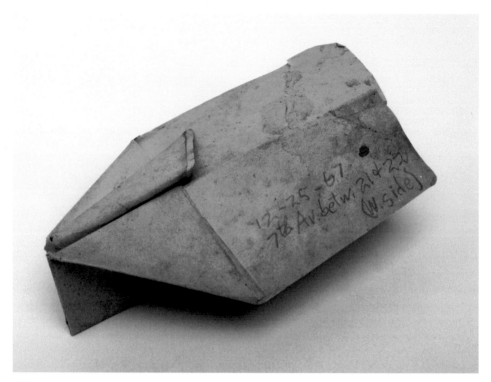

PA76

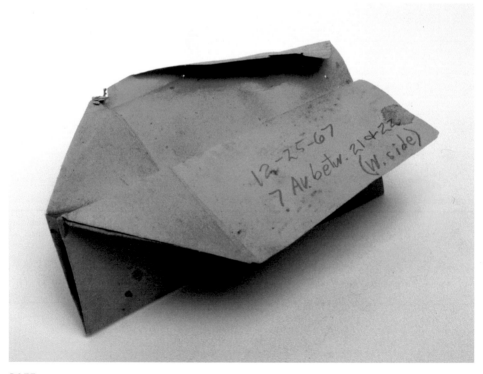

PA77

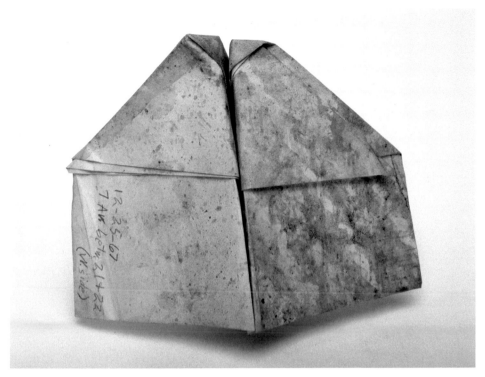

PA78

PA79

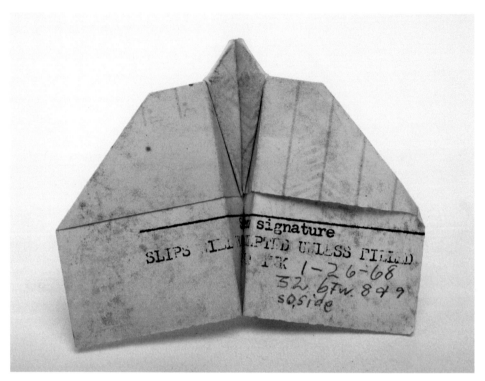

PA80

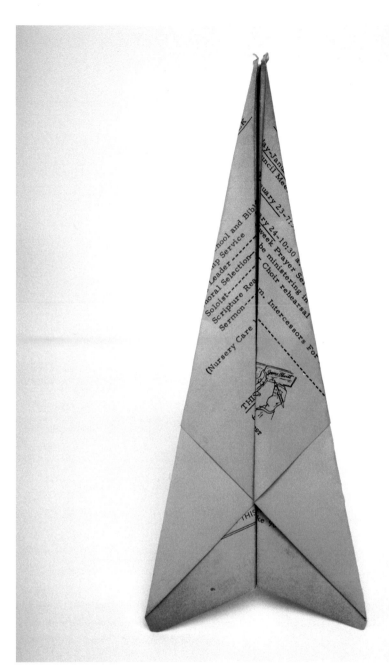

PA81

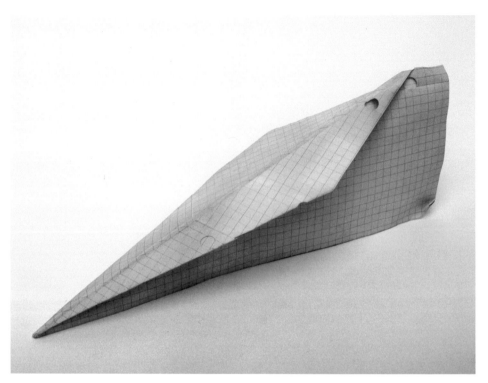

PA82

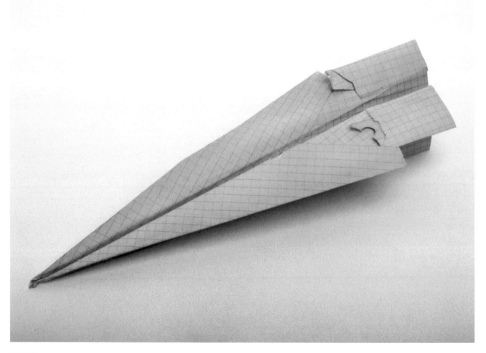

PA83

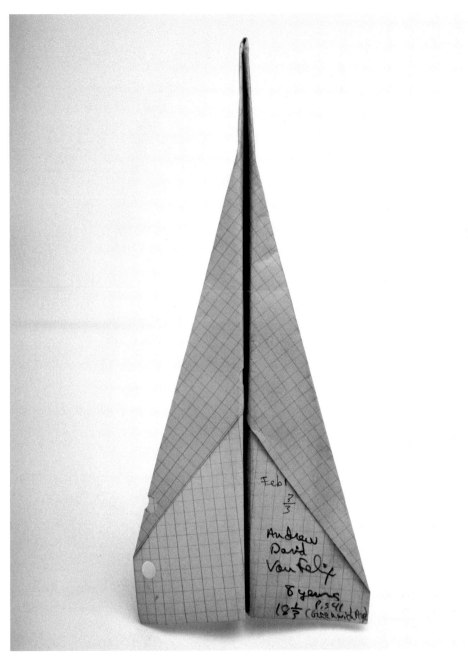

PA84

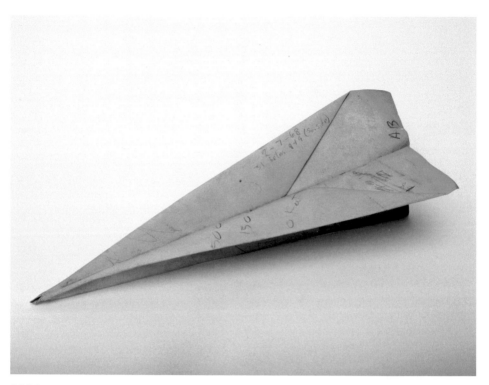

PA85

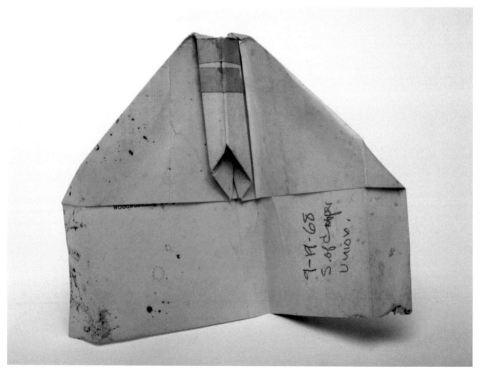

PA86

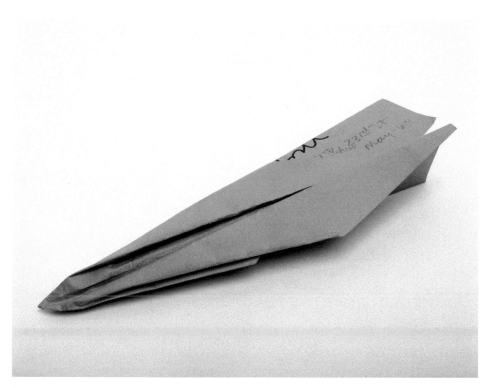

PA87

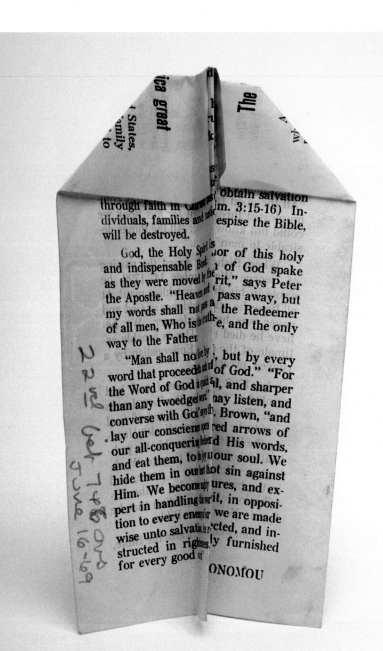

PA88

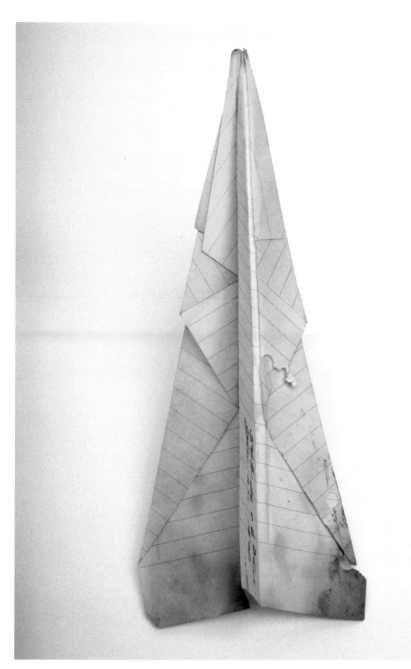

PA89

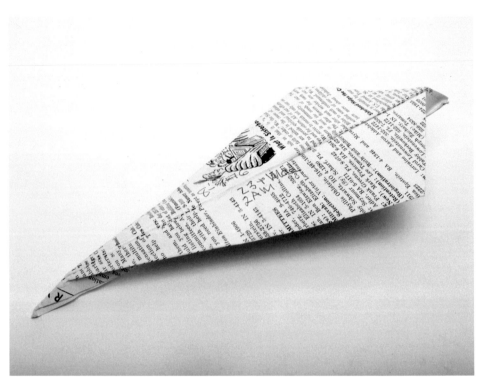

PA90

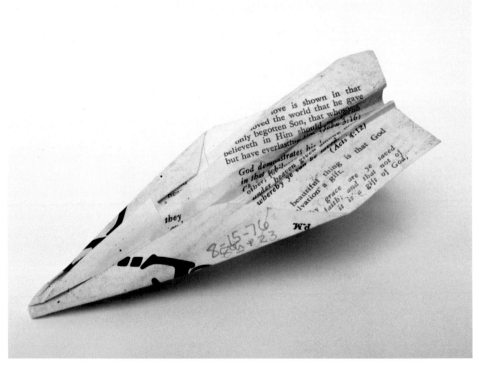

PA91

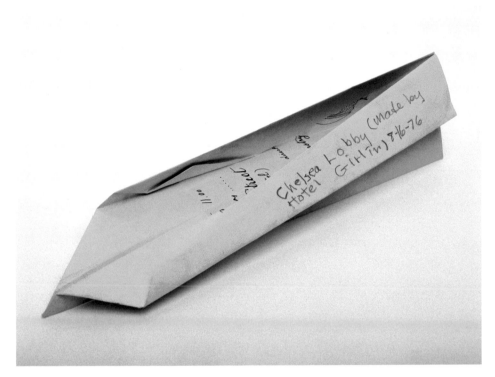

PA92

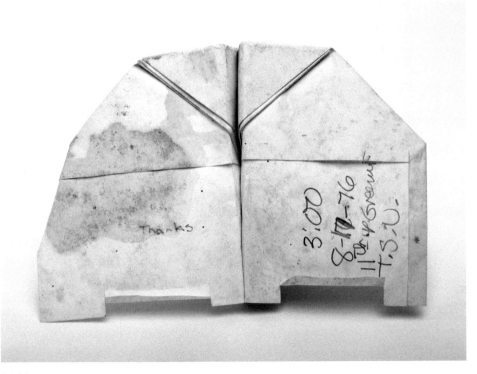

PA93

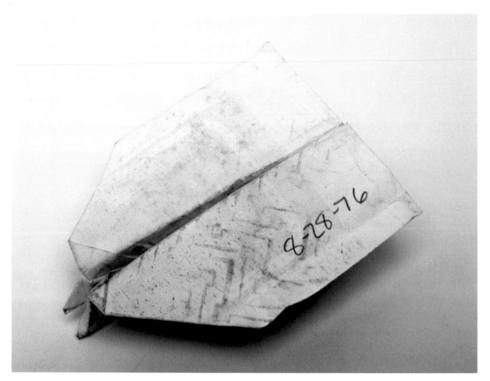

PA94

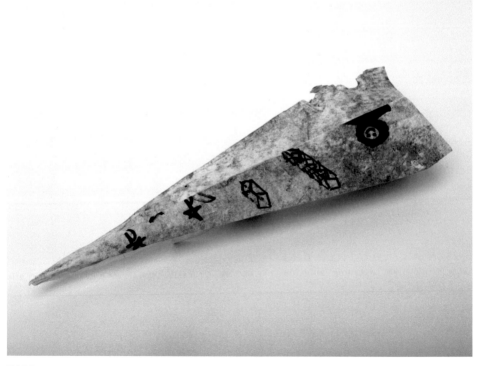

PA95

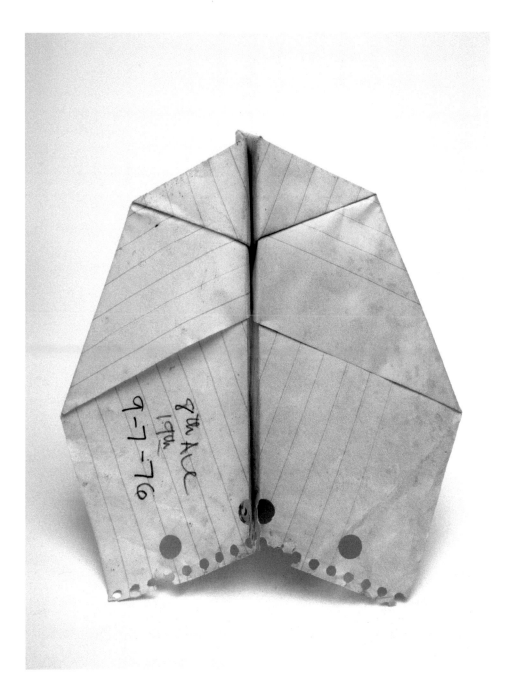

PA96

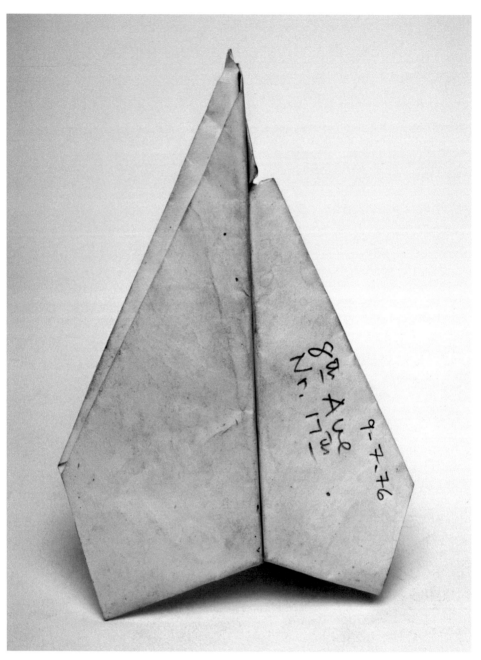

PA97

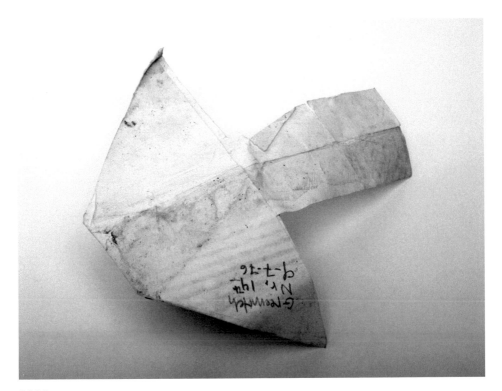

PA98

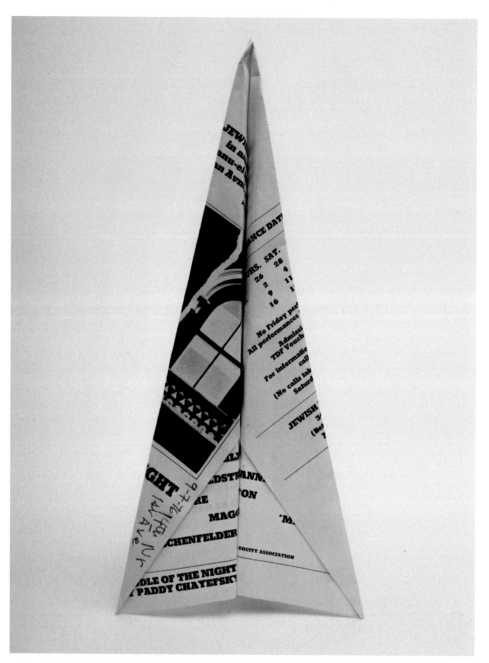

PA99

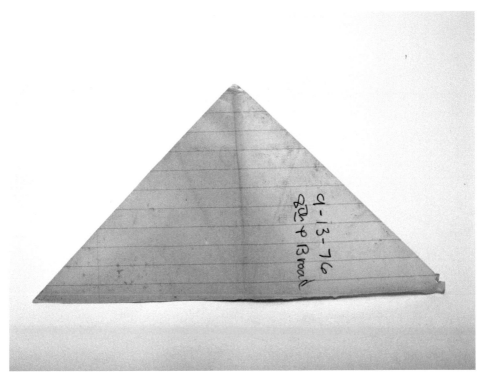

PA100

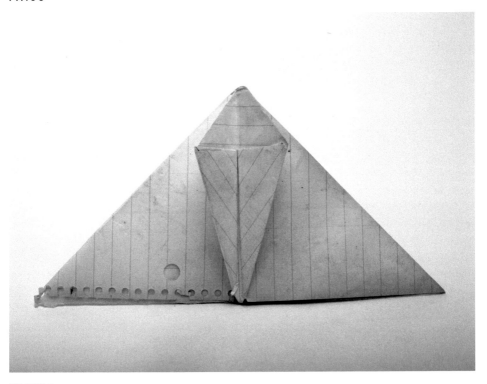

PA100a

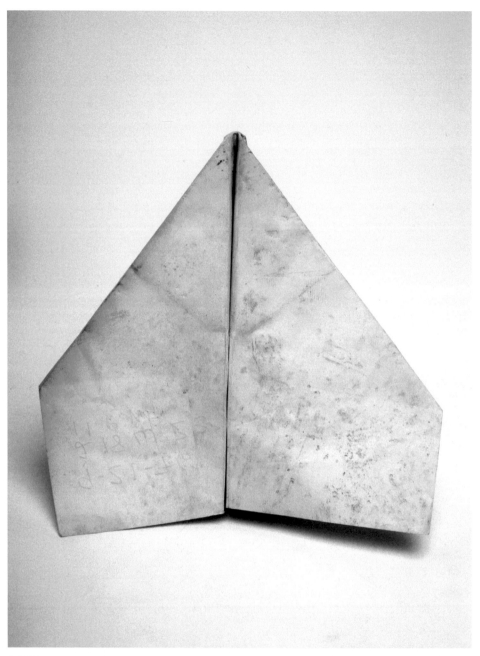

PA101

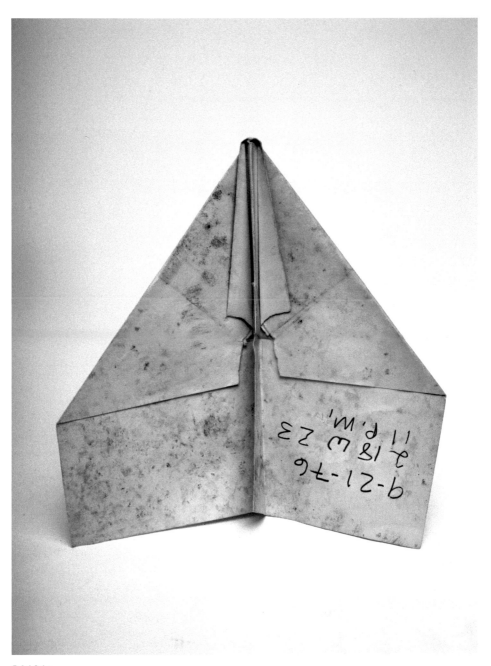

PA101a

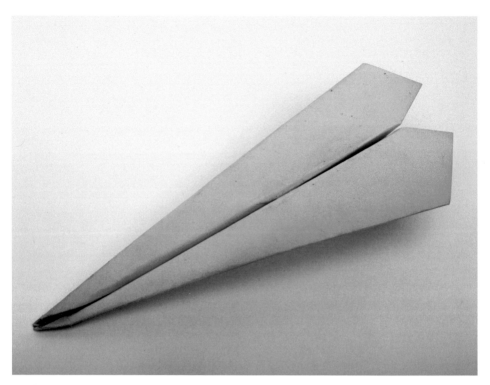

PA102

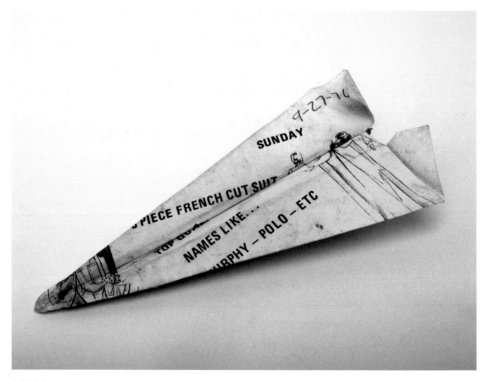

PA103

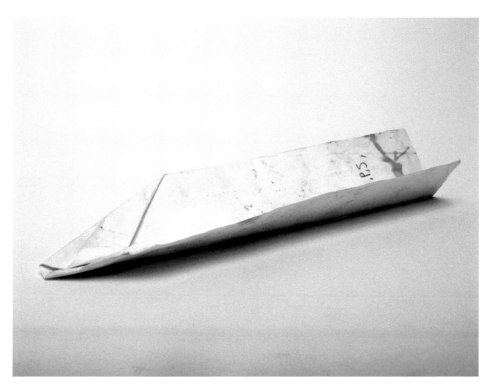

PA104

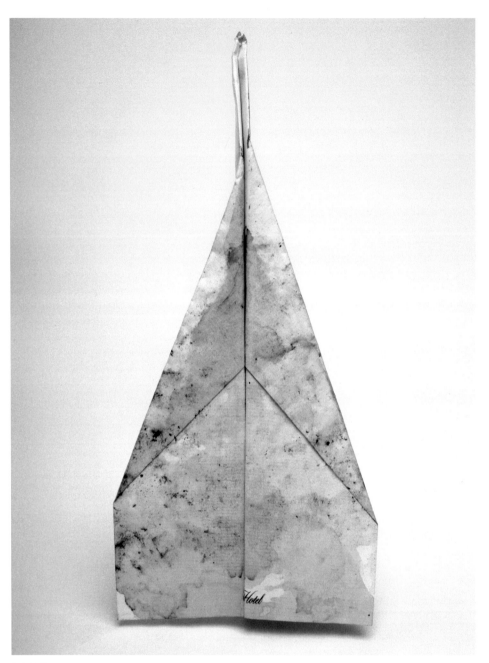

PA105

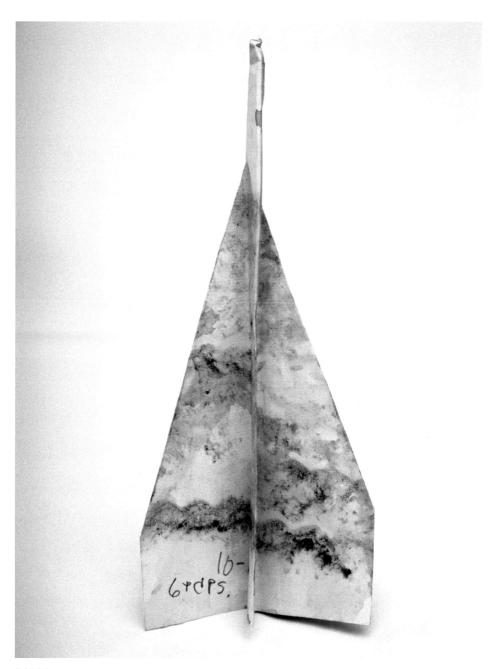

PA105a

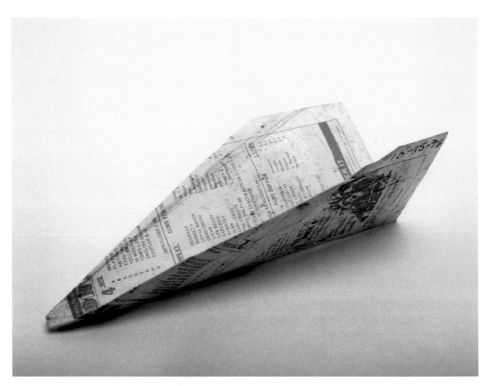

PA106

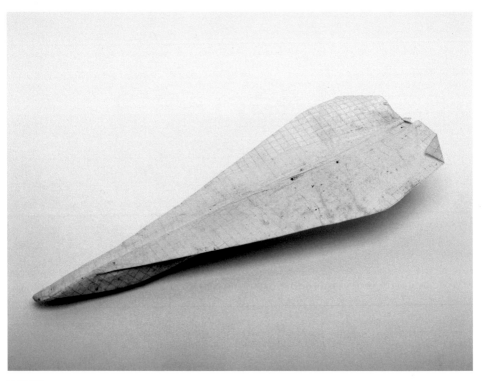

PA107

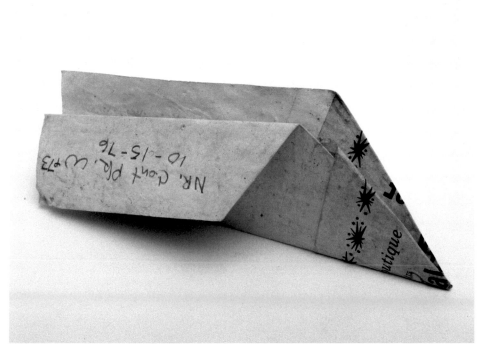

PA108

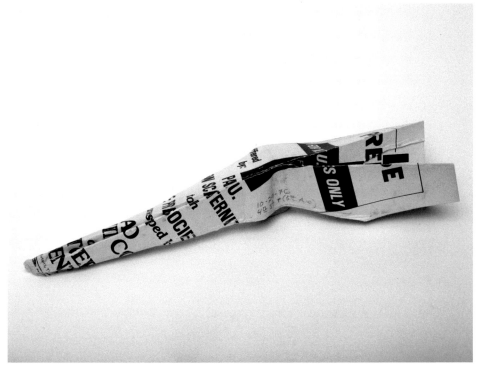

PA109

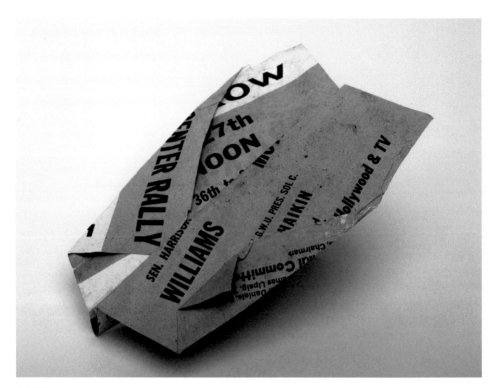

PA110

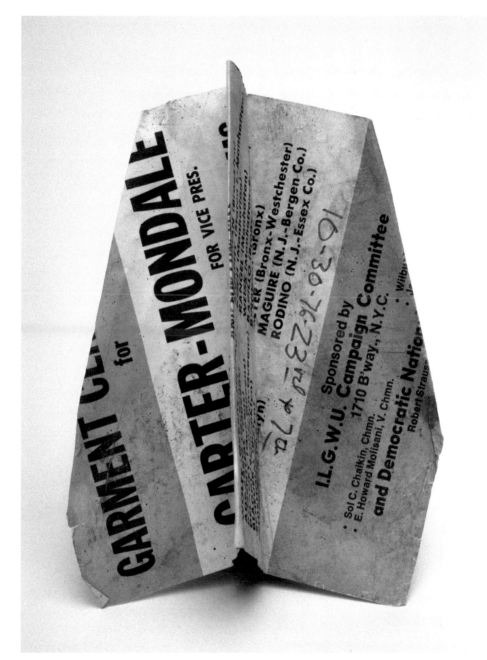

PA110a

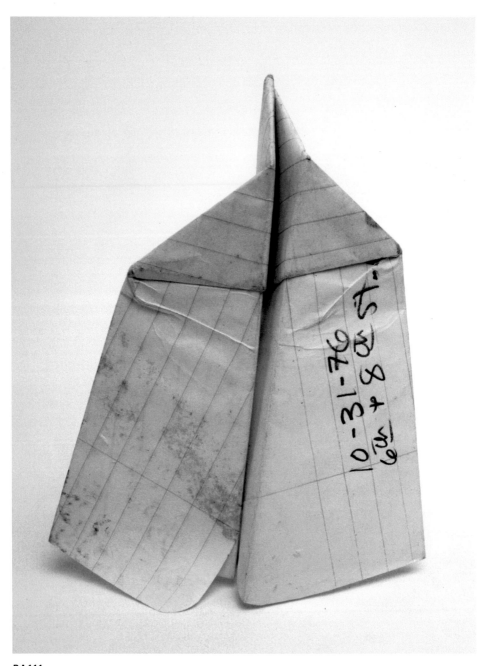

PA111

PA112

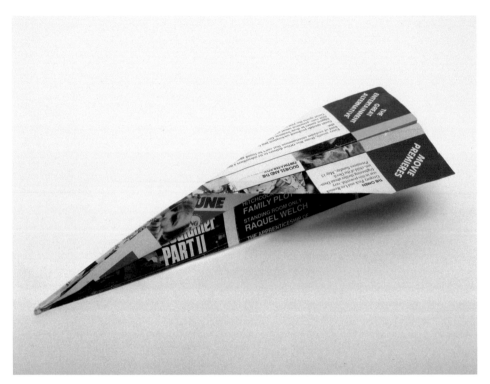

PA113

PA113a

PA114

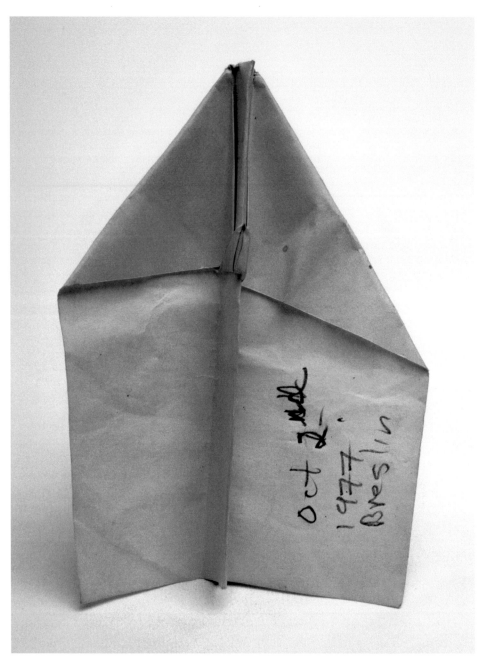

PA115

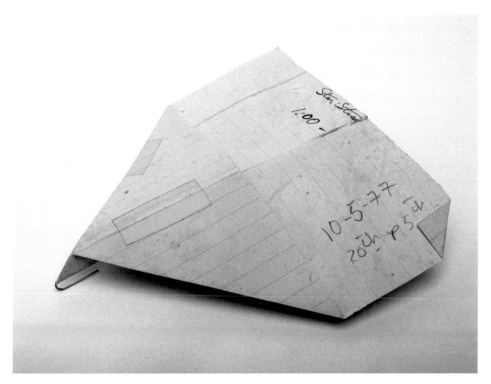

PA116

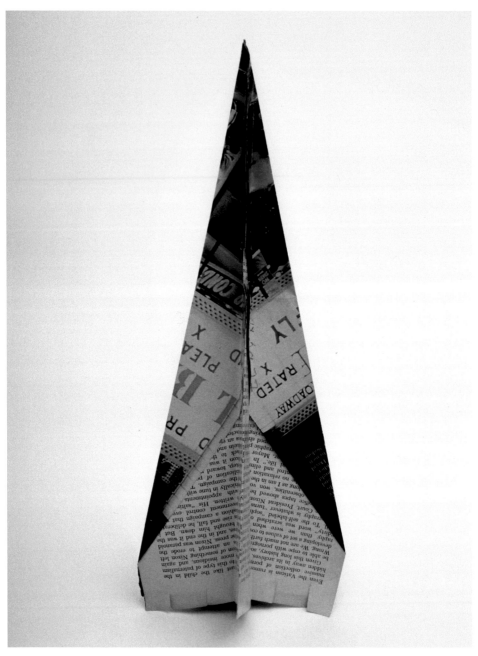

PA117

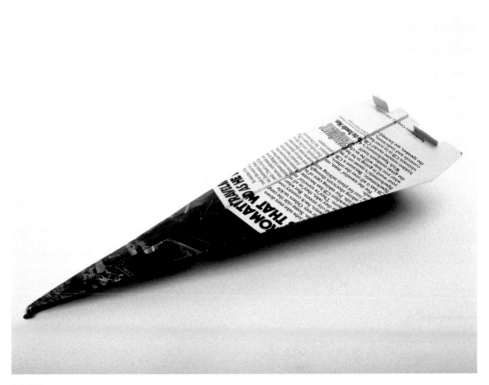

PA118

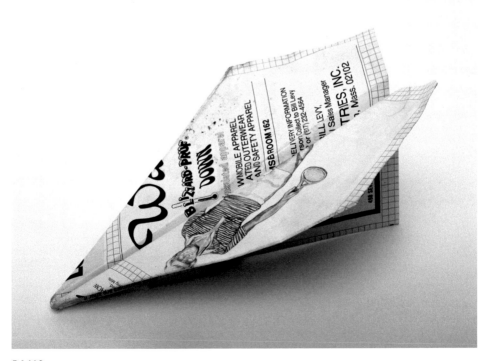

PA119

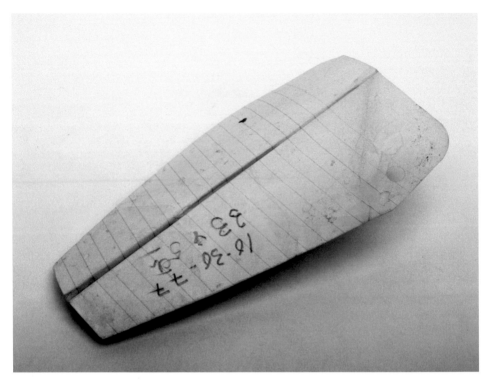

PA120

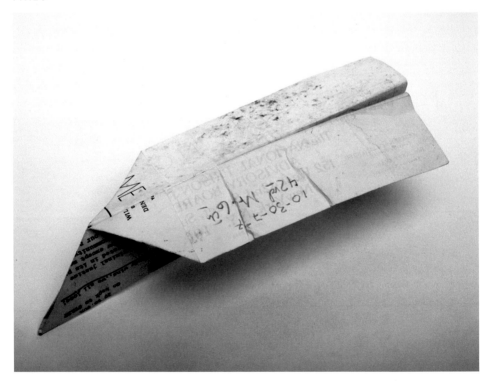

PA121

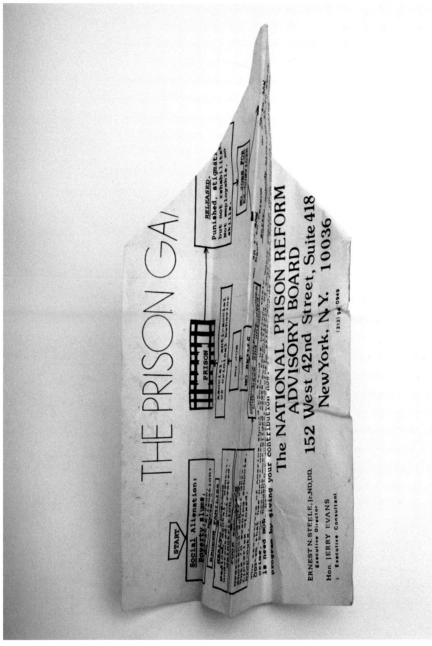

PA121a

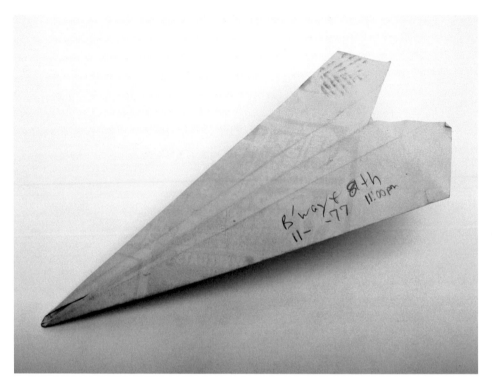

PA122

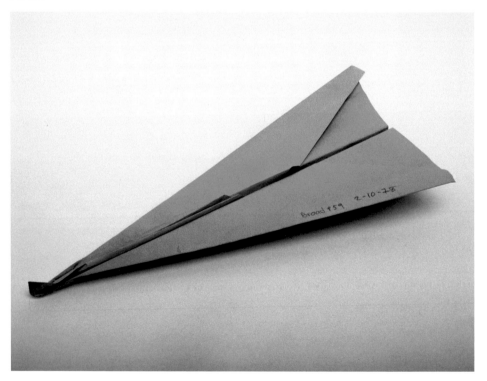

PA123

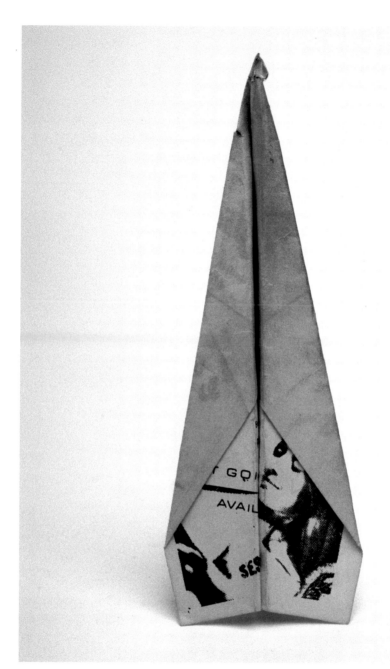

PA124

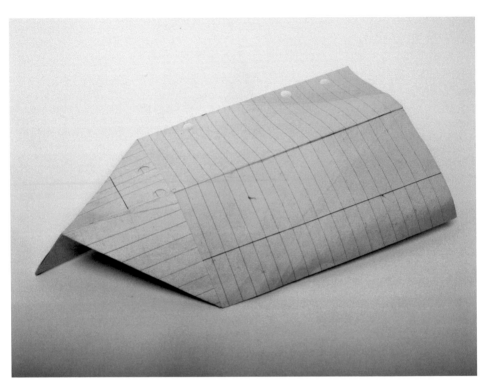

PA125

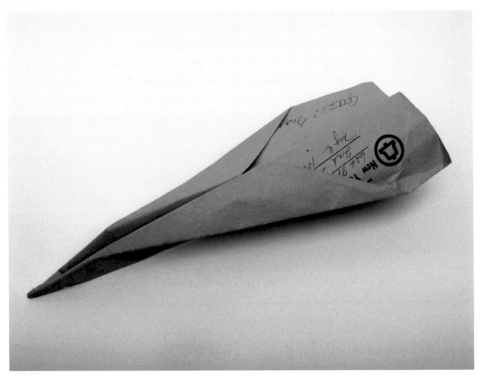

PA126

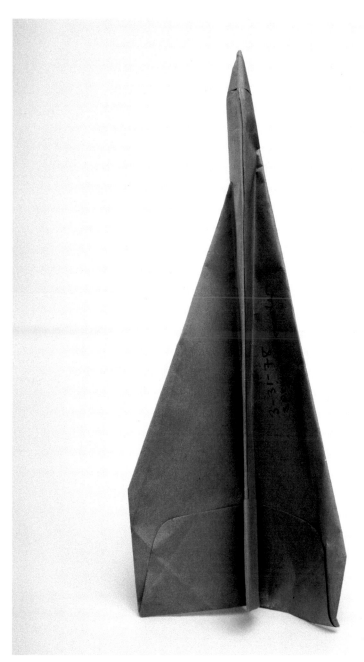

PA126a

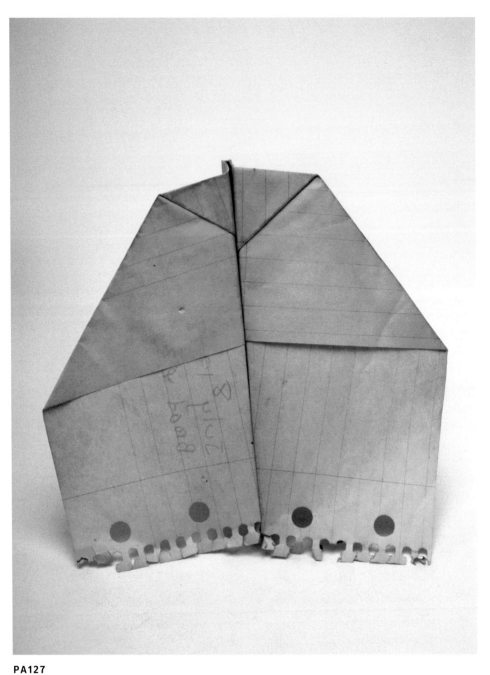

PA127

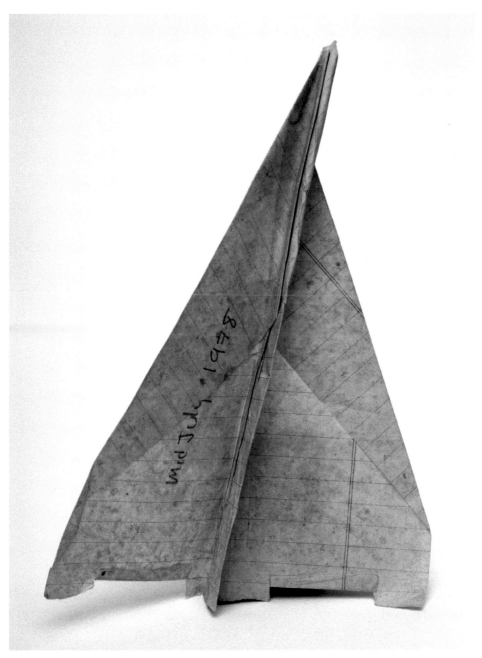

PA128

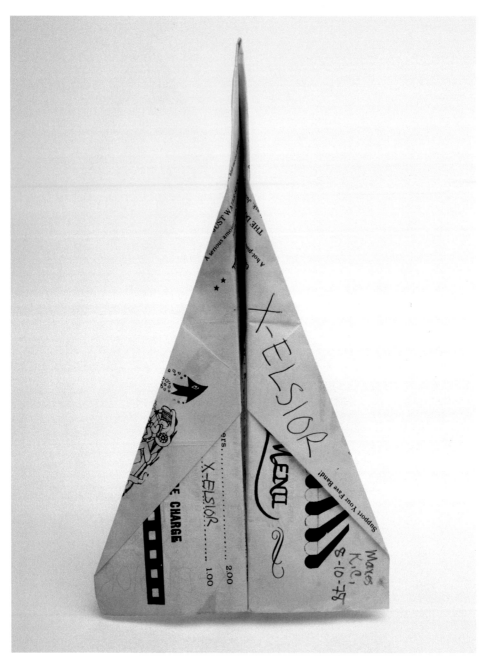

PA129

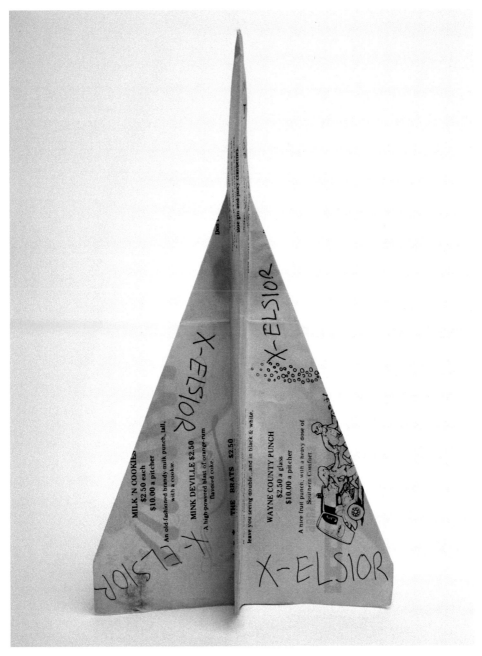

PA129a

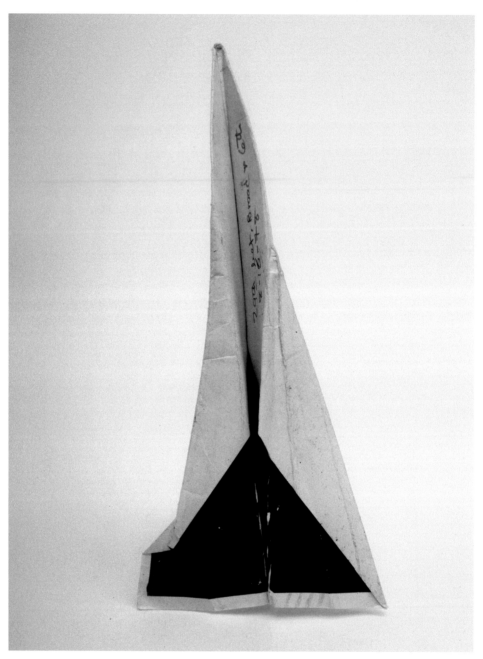

PA130

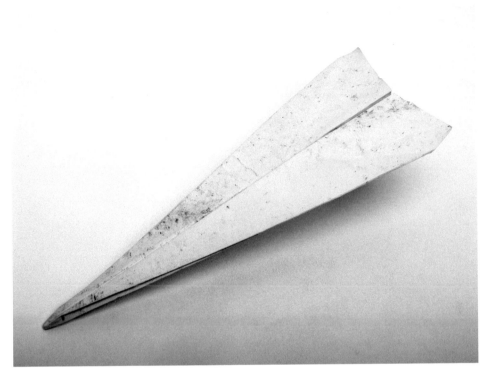

PA131

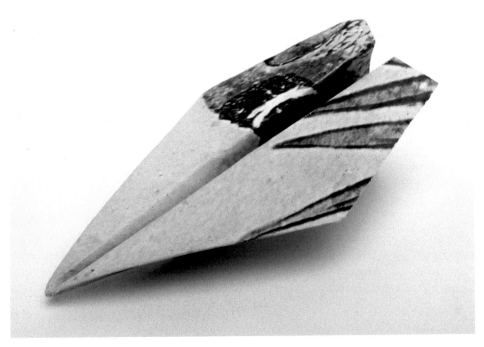

PA132

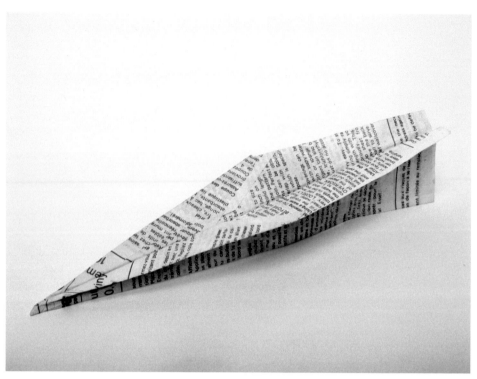

PA133

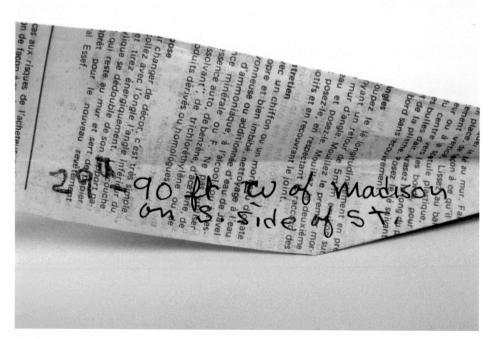

PA133a

PA133b

les lés à une longu...
à 5 cm à la hauteur à ta
compte bien entendu du
des motifs (pour un d
d) ou brutalement de l
nt (pour un... n sans racc
age (pour les articles pré-en
le bac à eau à remplir le
oulez le lé sur lui-même,
eur, en commençant pa
sin. Plongez-le dans le ba
0 secondes. Saisissez le l
upérieurs et déroulez-le le
e rouleau en mousse : po
rs sur une table. Mouill
nt avec le rouleau. Rep
tefeuille.

9-21-78
3:00 pm

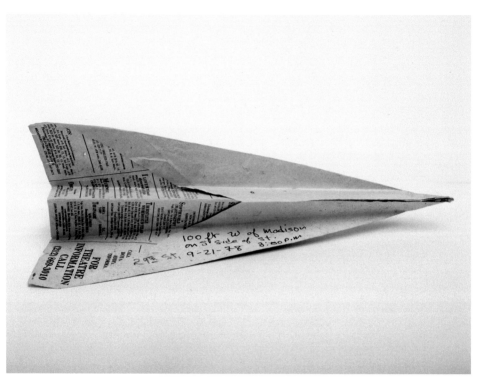

PA134

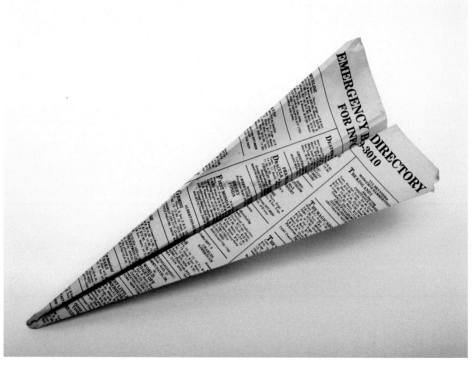

PA135

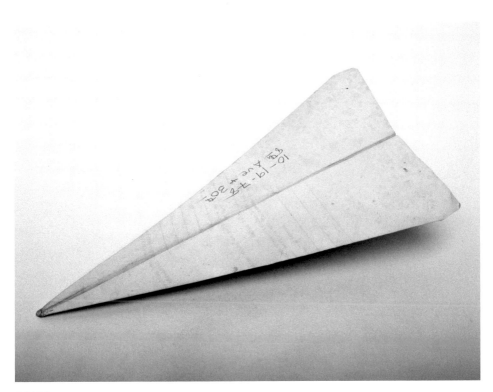

PA136

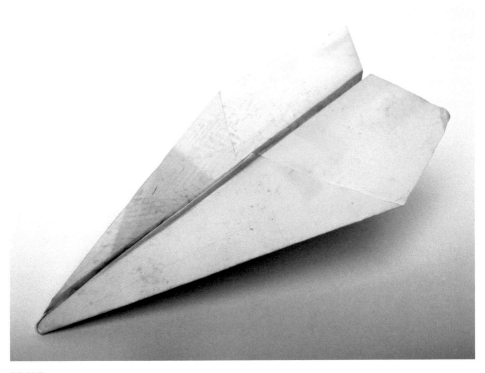

PA137

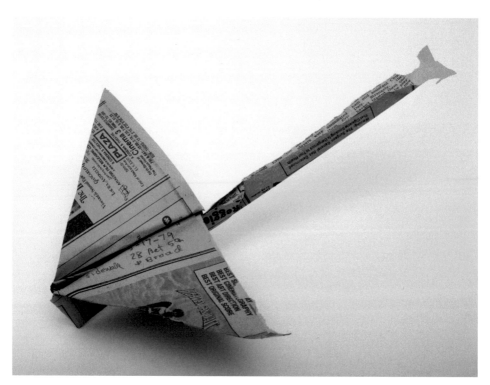

PA138

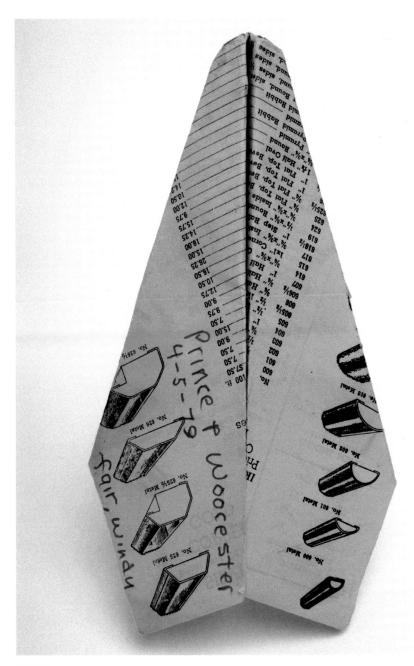

PA139

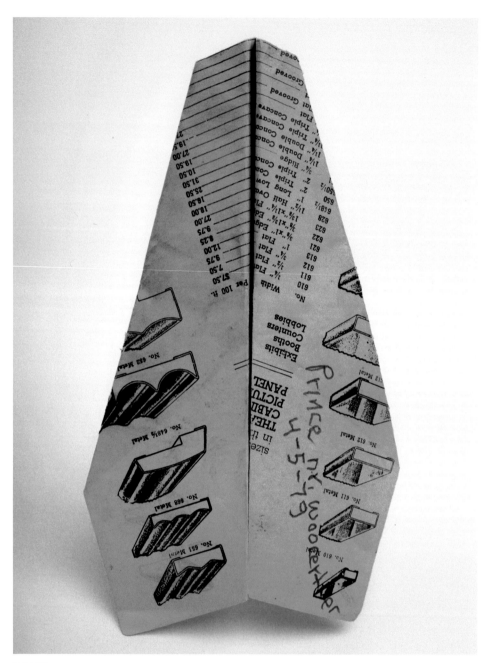

PA140

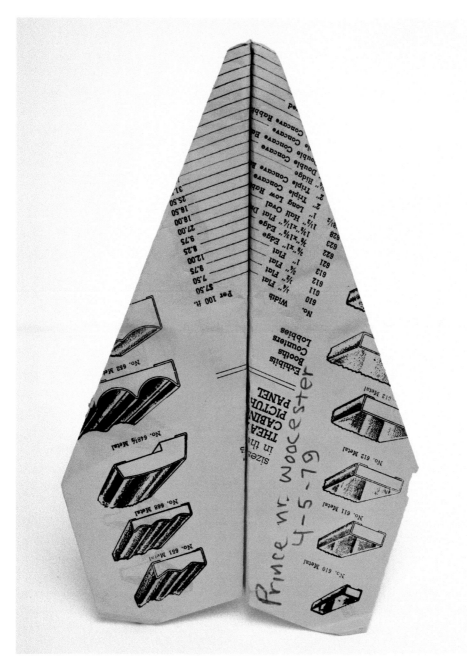

Prince Nr Woocester 4-5-79

PA141

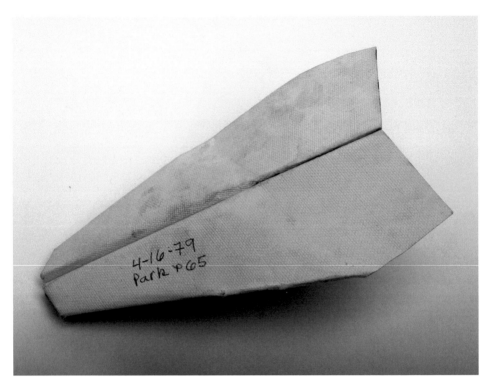

PA142

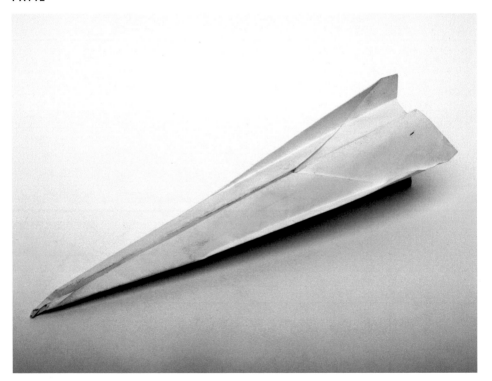

PA143

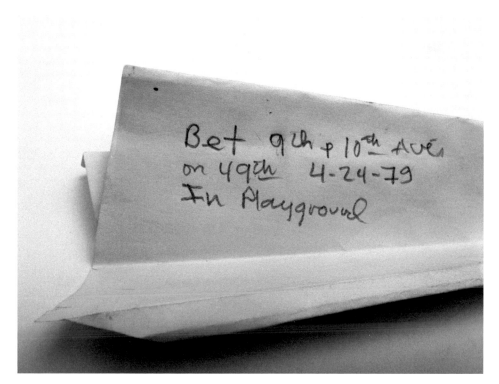

PA143a

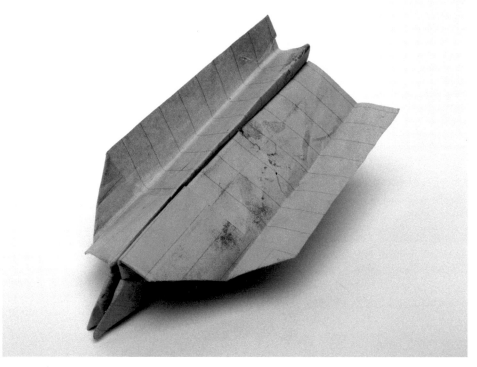

PA144

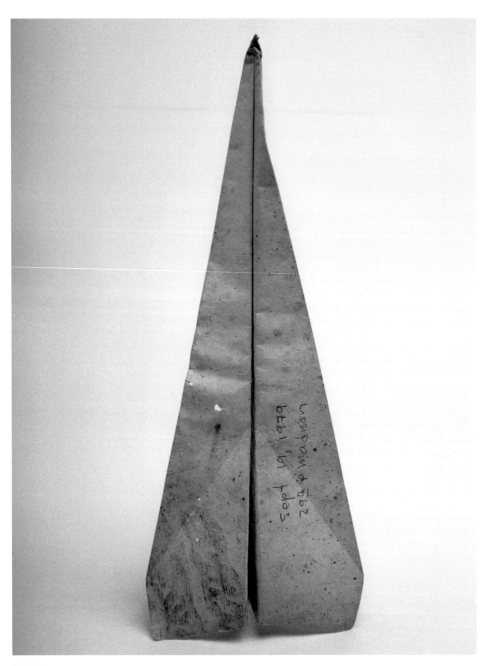

PA145

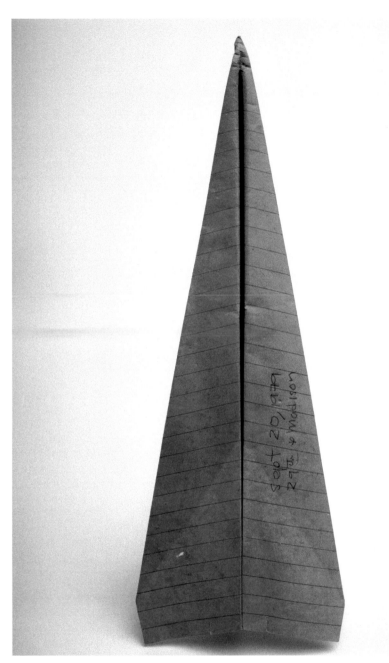

PA146

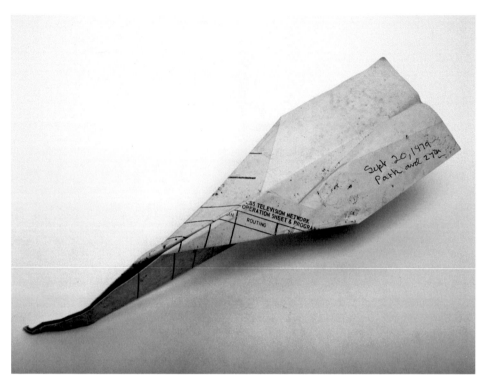

PA147

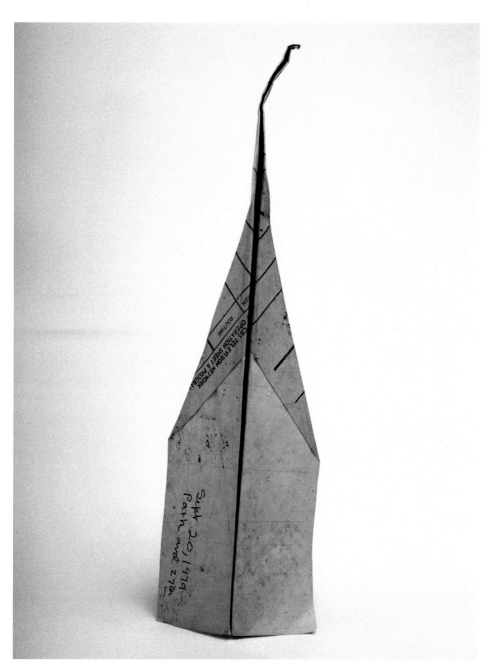

PA147a

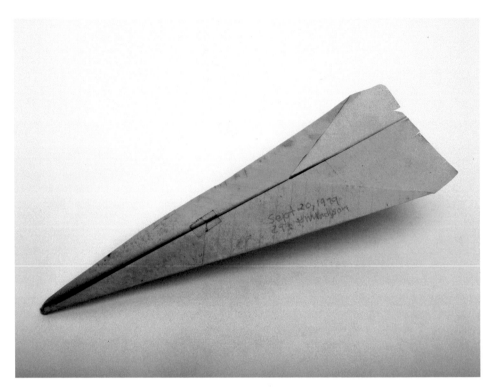

PA148

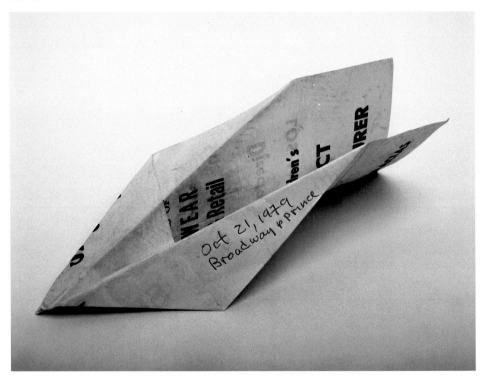

PA149

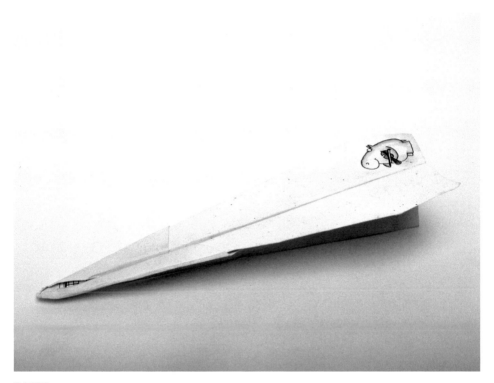

PA150

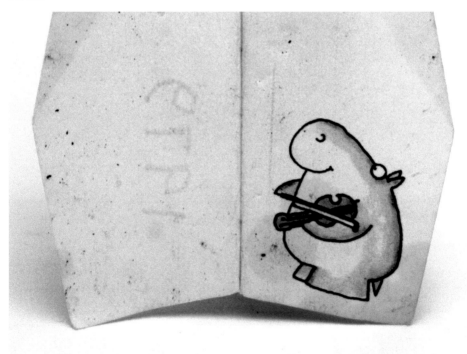

PA150a

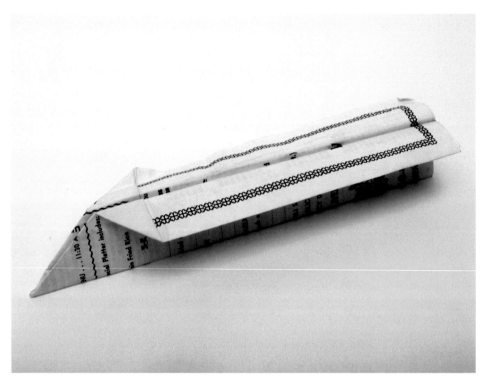

PA151

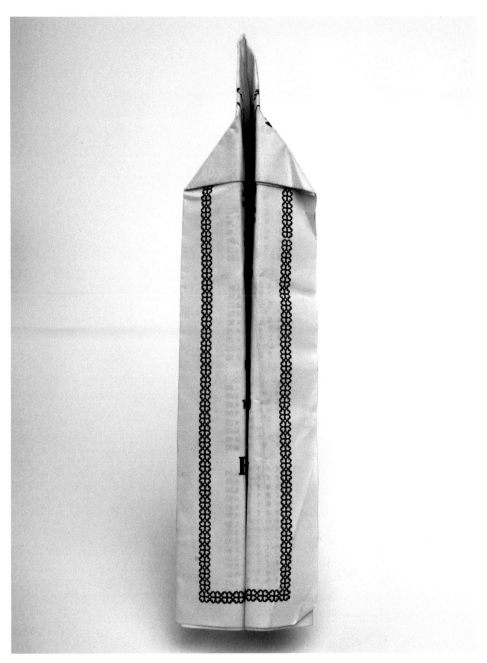

PA151a

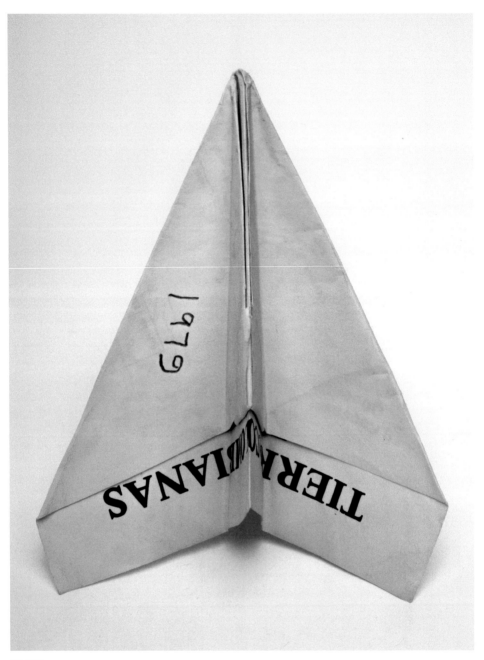

PA152

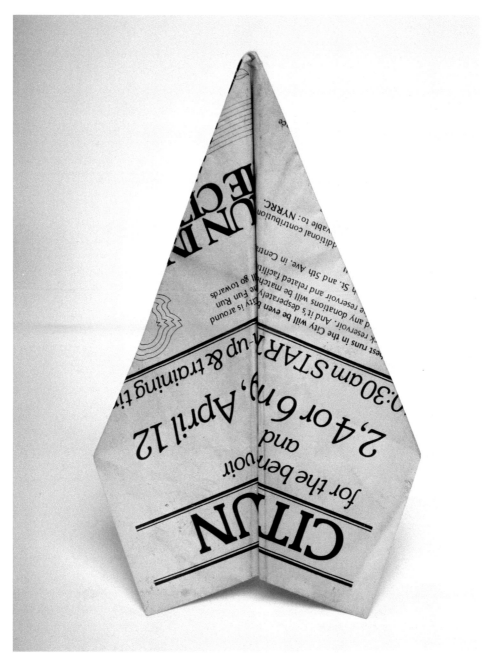

PA153

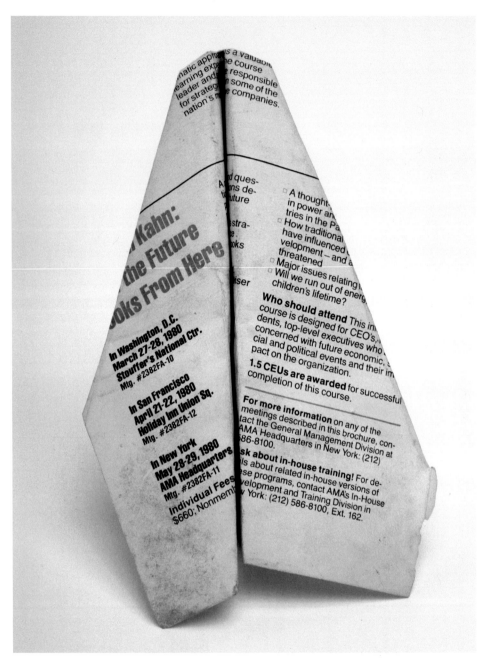

PA154

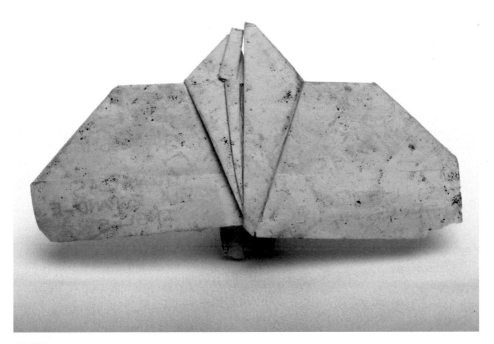

PA155

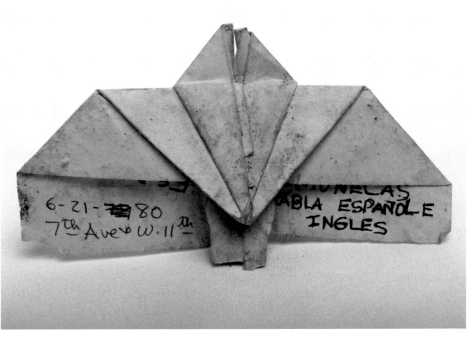

PA155a

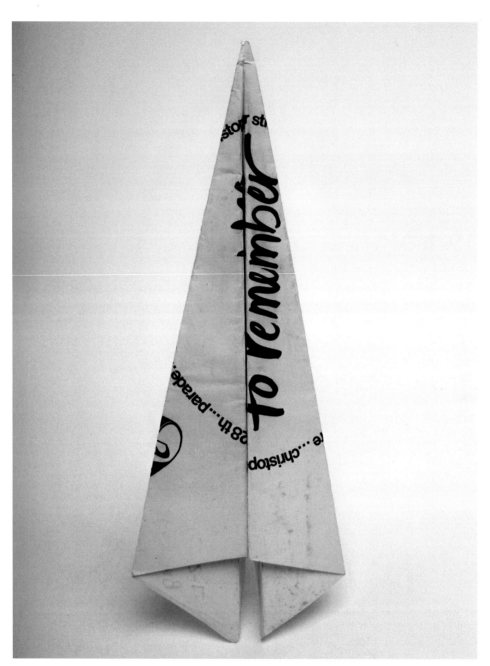

PA156

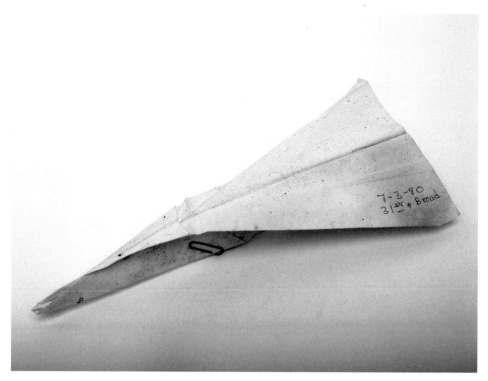

PA157

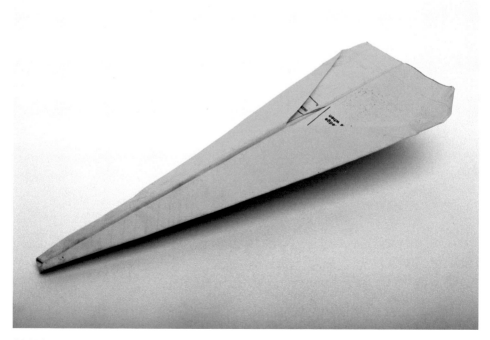

PA158

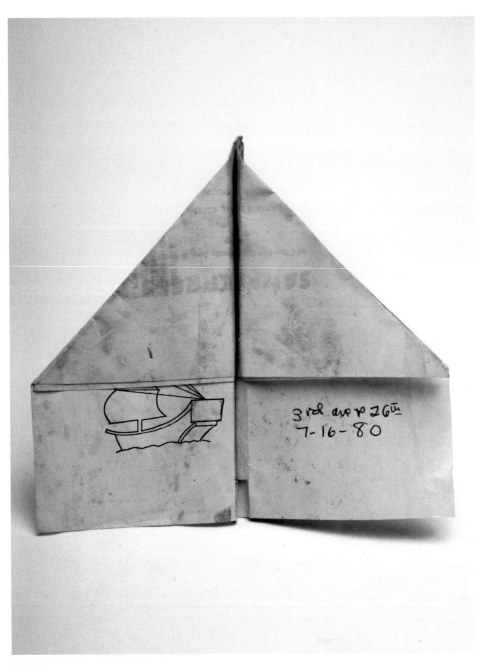

PA159

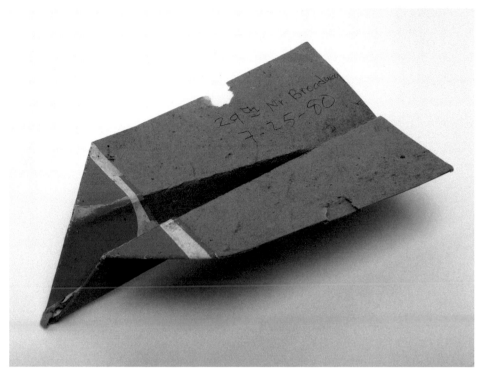

PA160

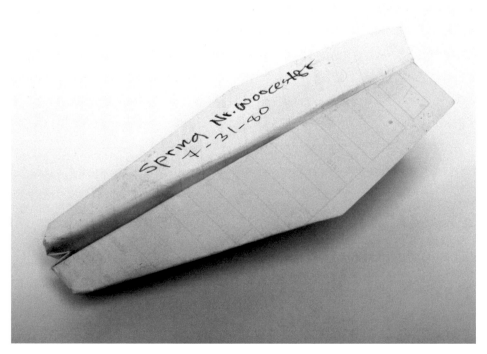

PA161

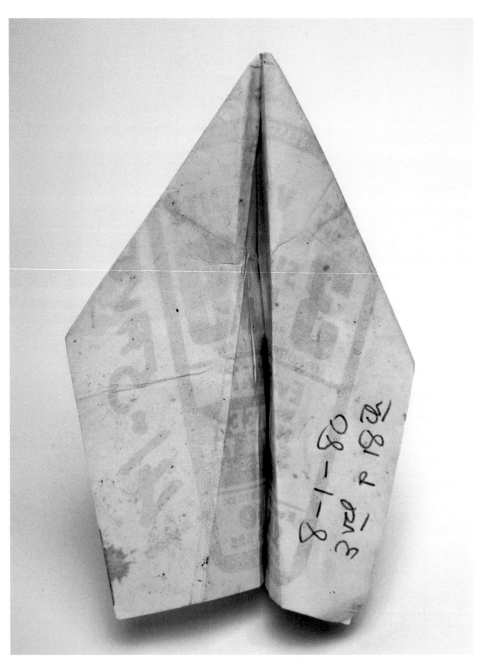

PA162

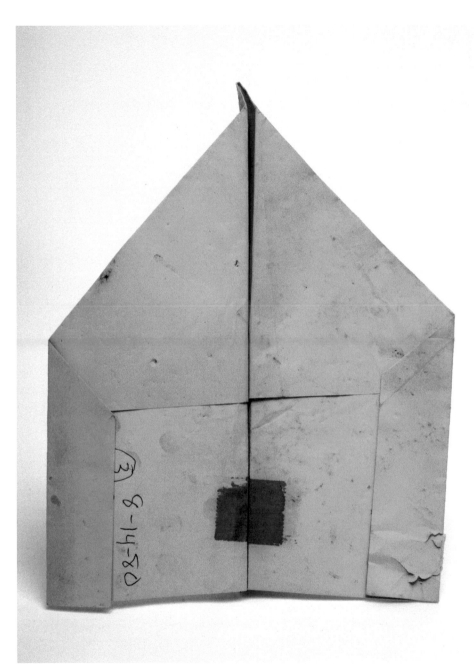

PA163

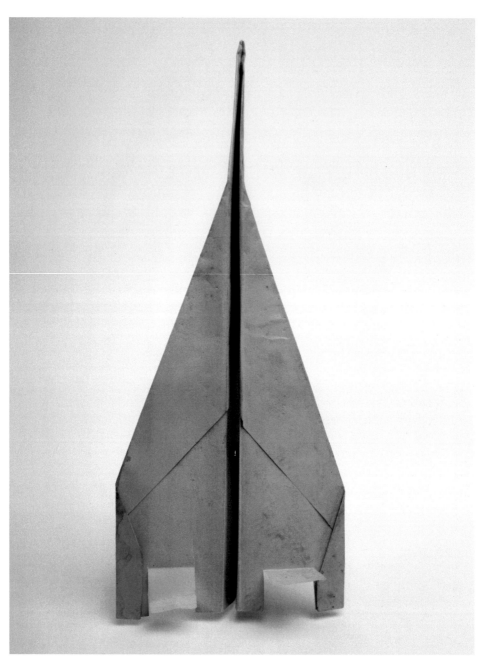

PA164

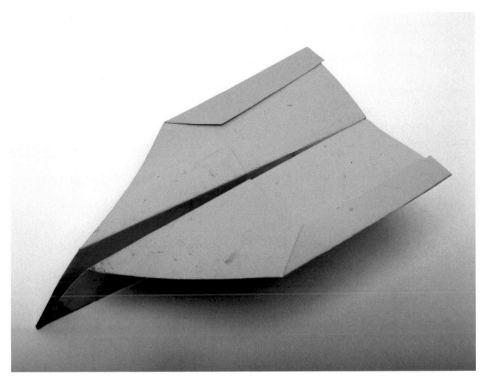

PA165

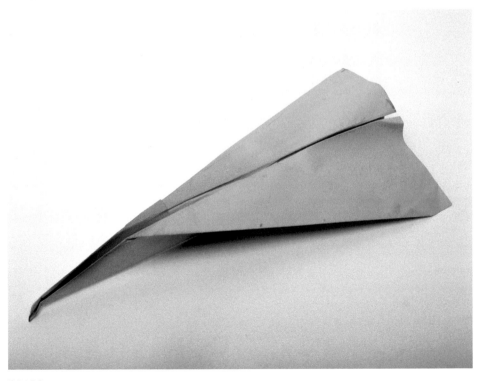

PA166

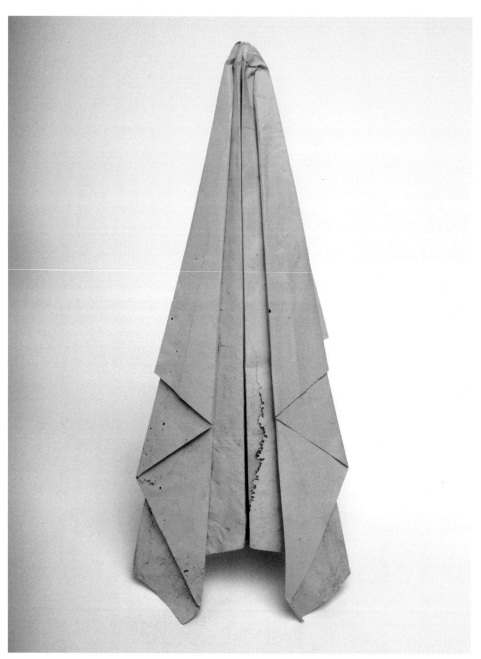

PA167

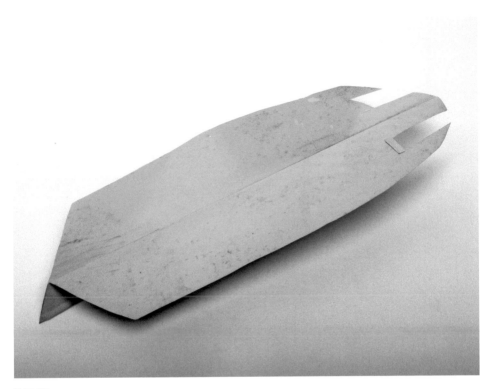

PA168

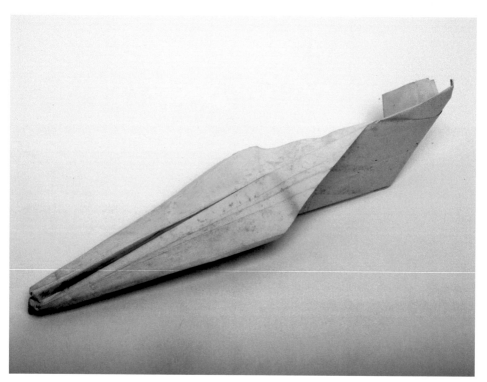

PA169

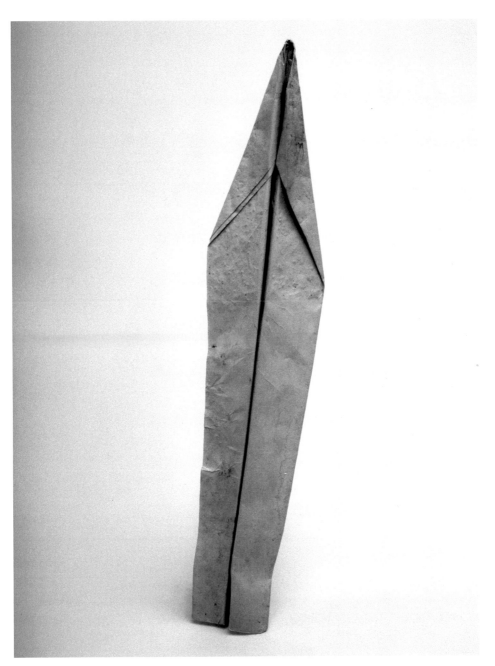

PA170

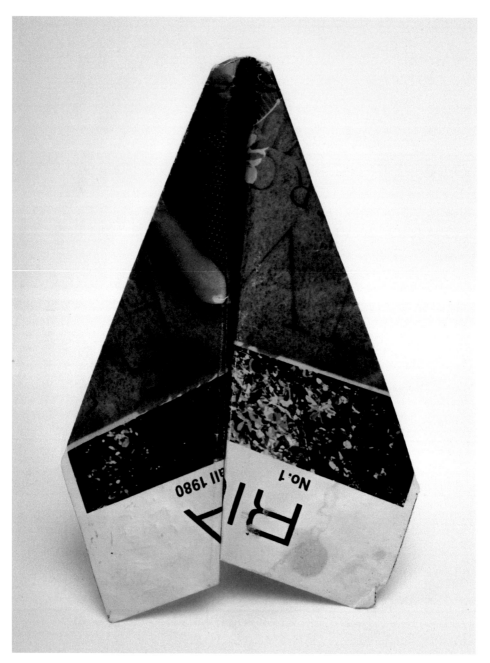

PA171

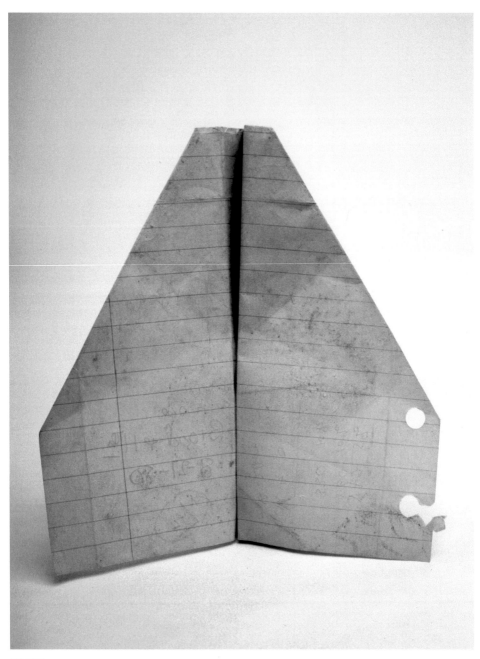

PA173

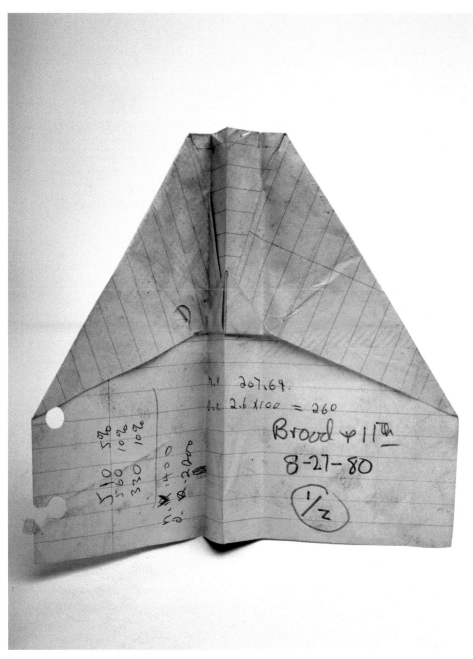

PA173a

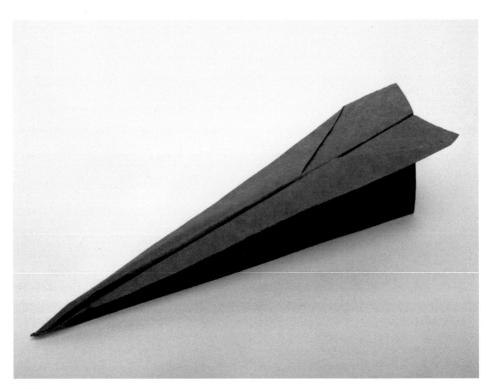

PA174

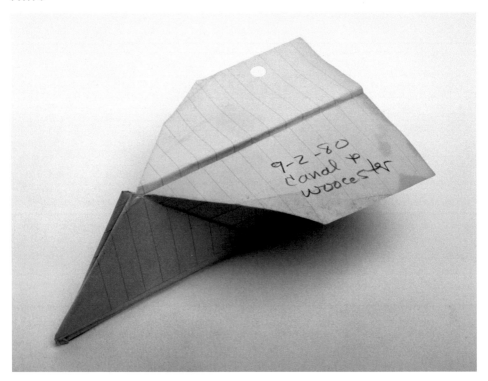

PA175

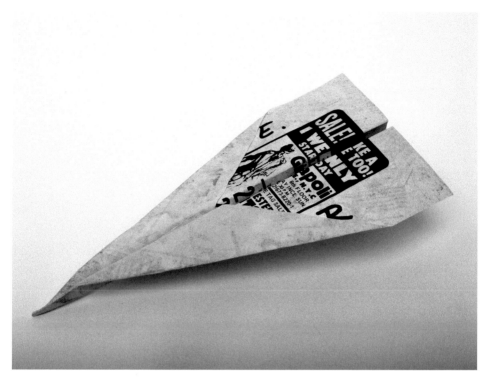

PA176

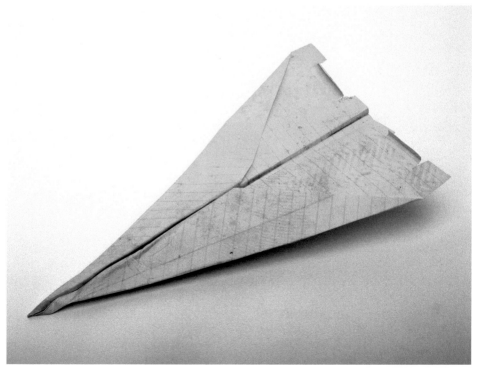

PA177

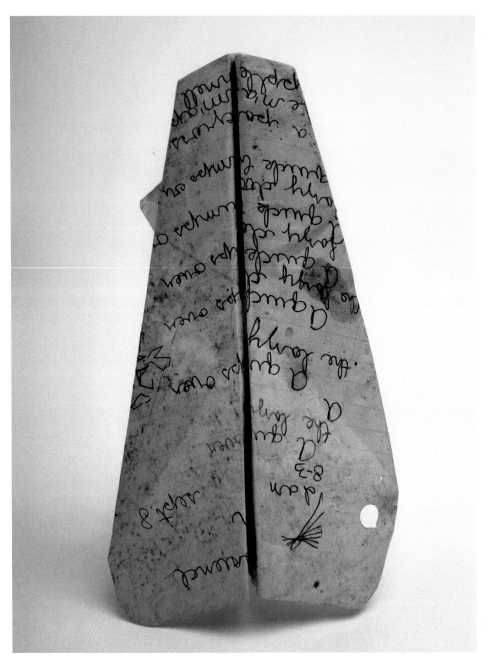

PA178

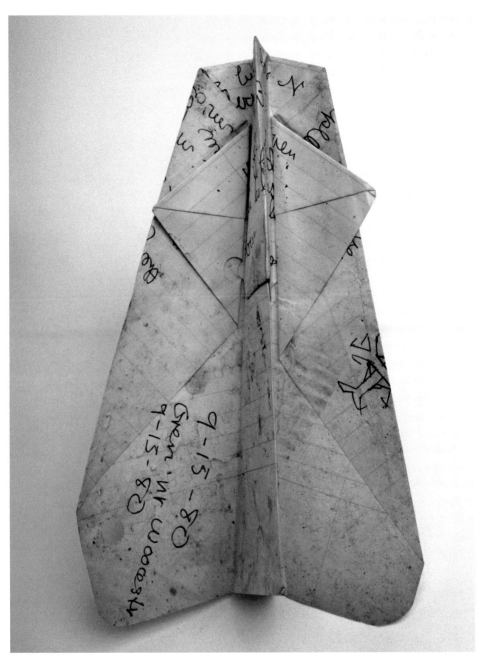

PA178a

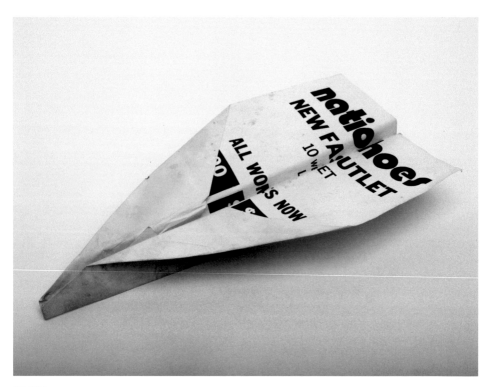

PA179

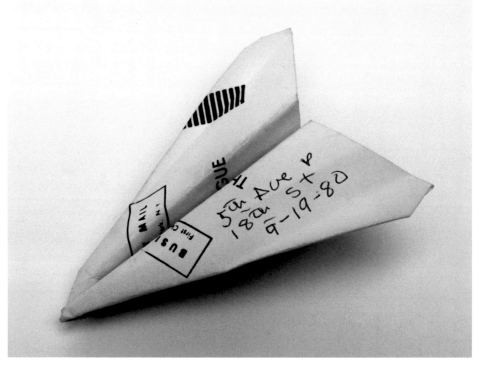

PA180

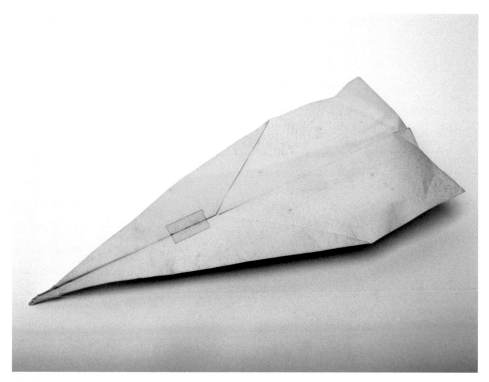

PA181

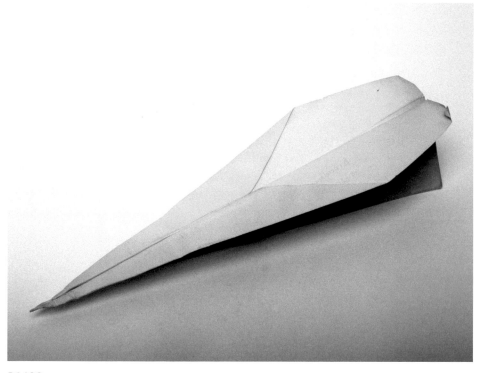

PA182

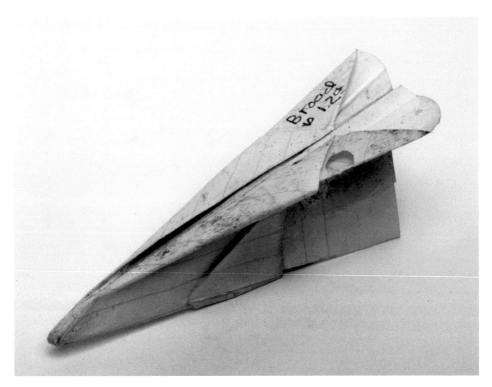

PA183

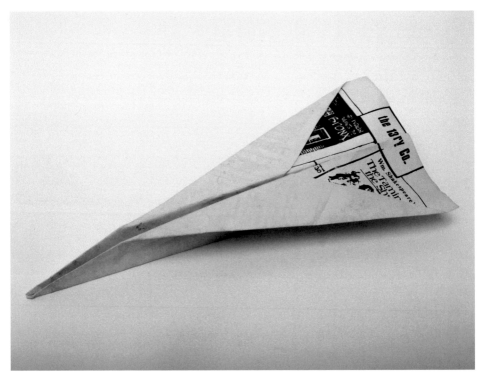

PA184

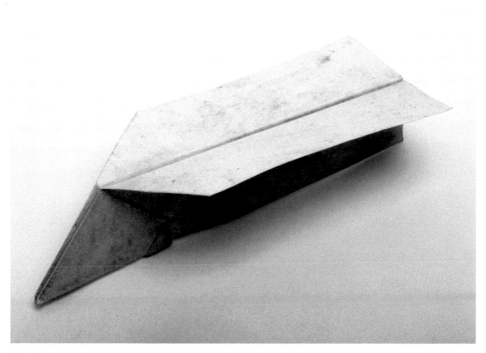

PA185

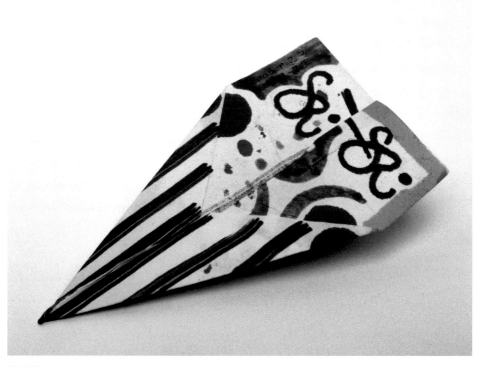

PA186

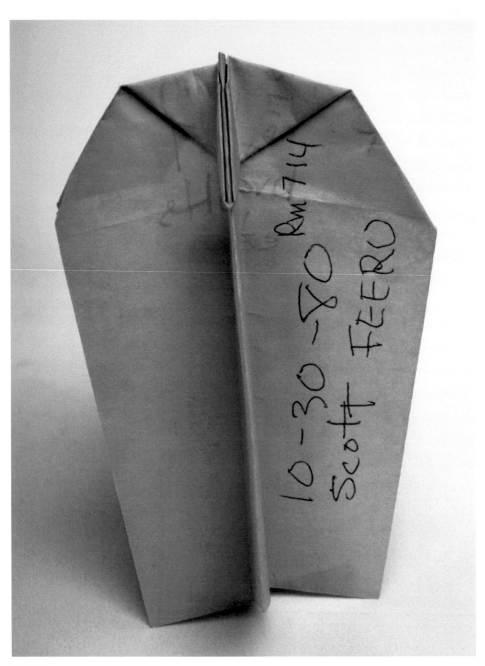

PA187

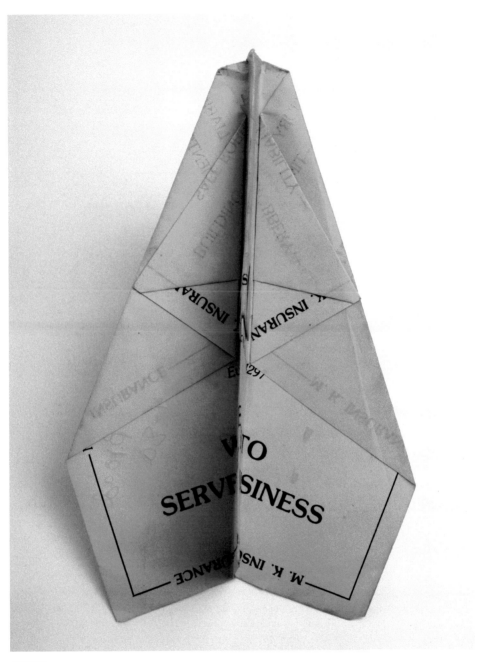

PA188

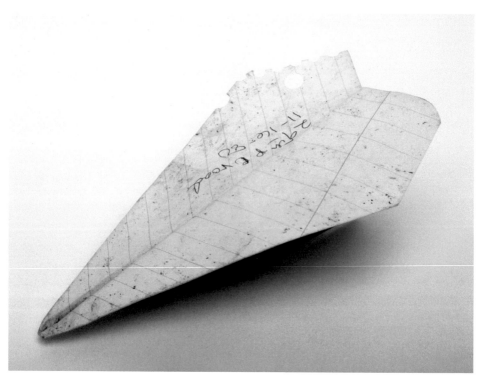

PA189

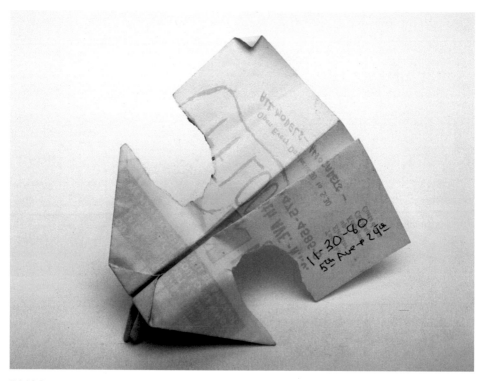

PA190

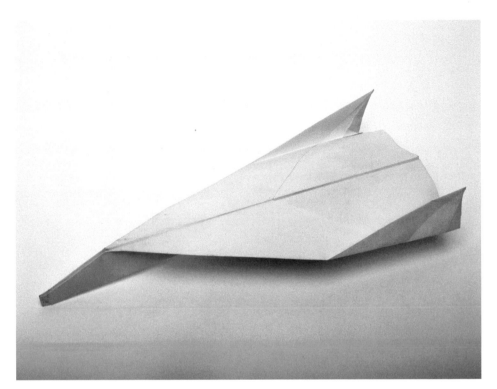

PA191

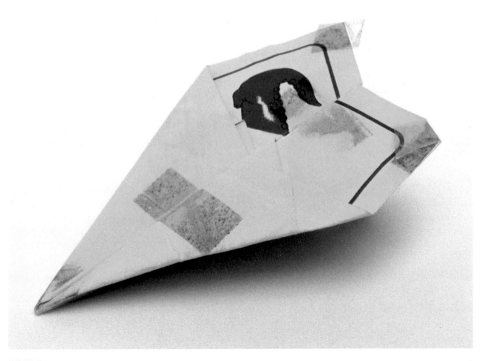

PA192

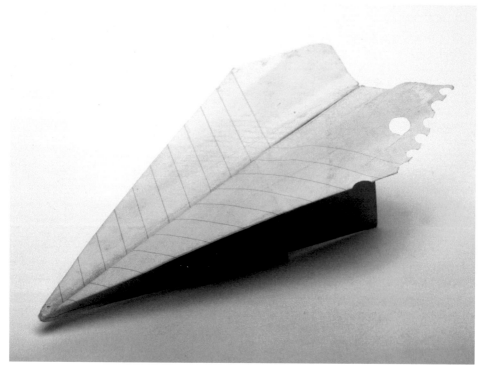

PA193

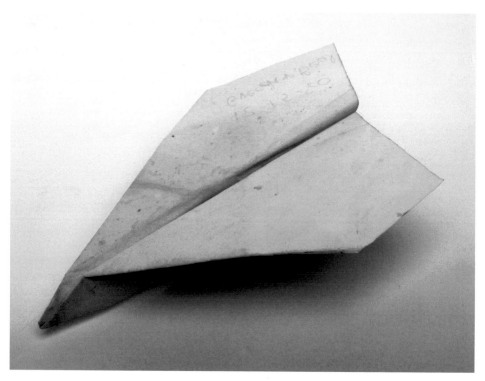

PA194

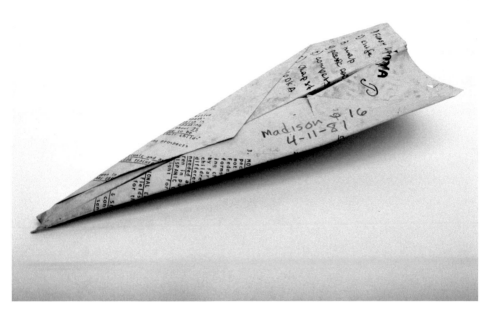

PA195

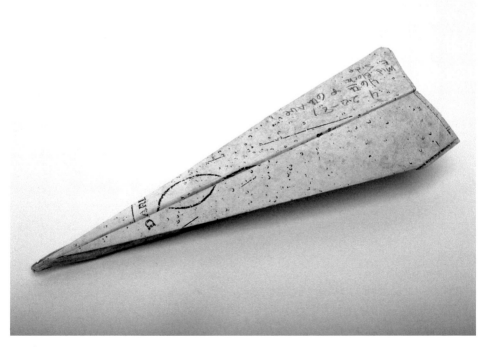

PA196

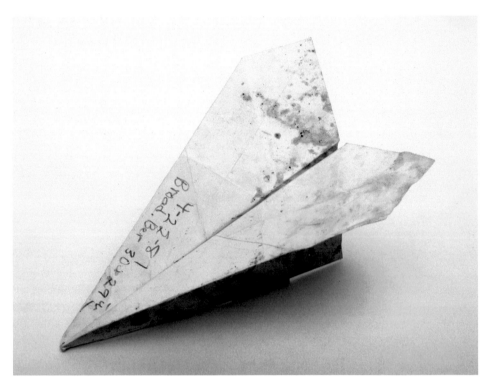

PA197

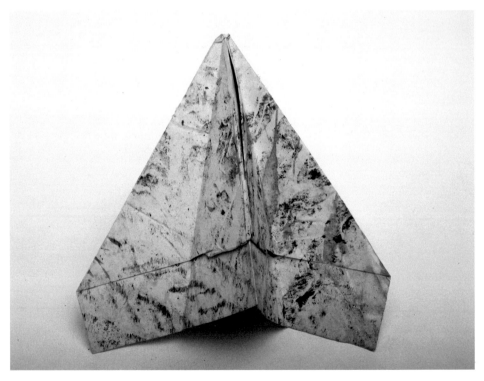

PA197a

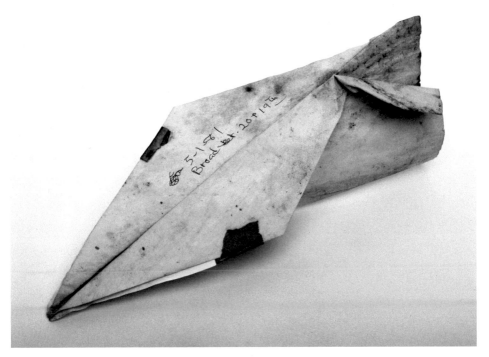

PA198

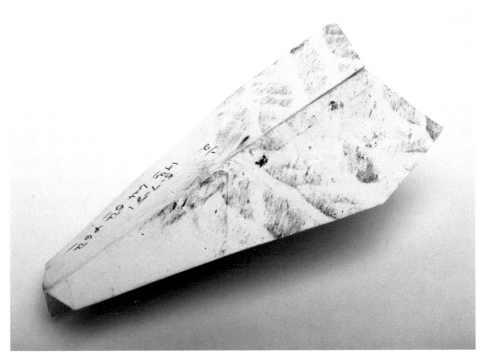

PA199

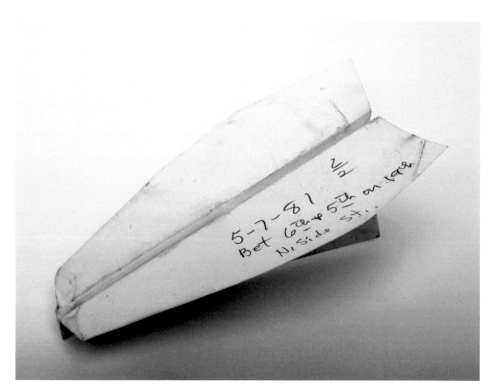

PA200

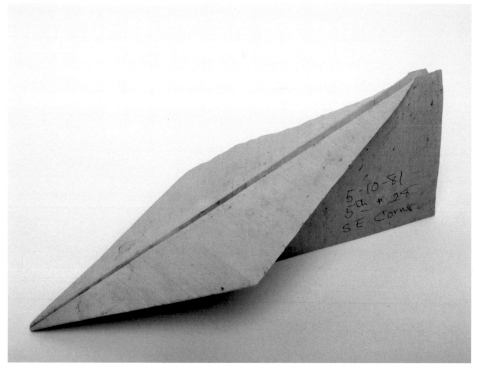

PA201

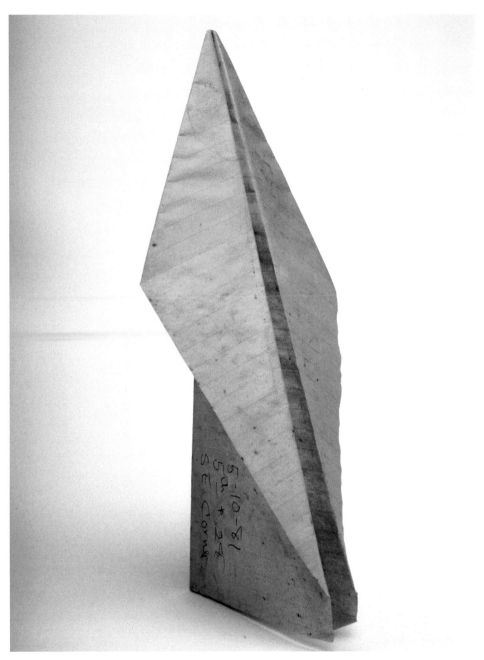

PA201a

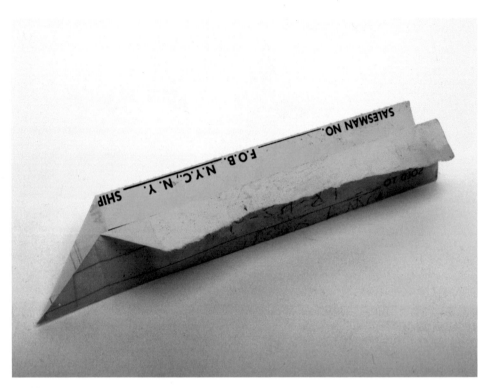

PA202

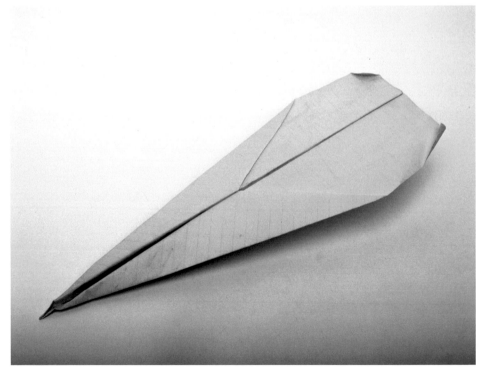

PA203

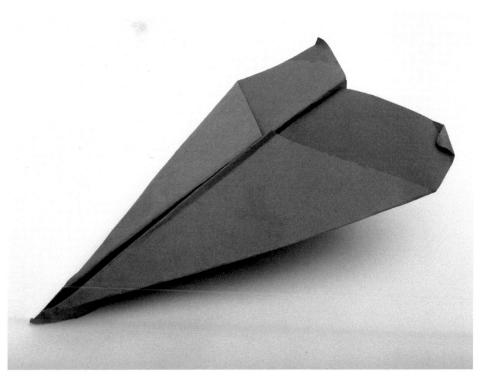

PA204

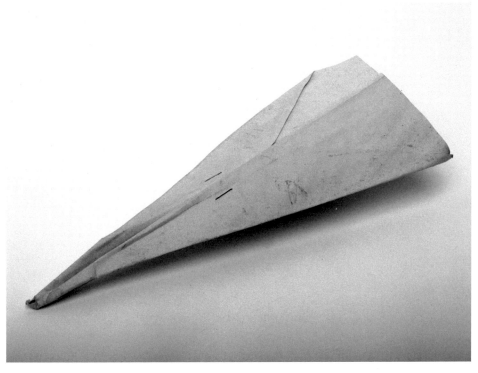

PA205

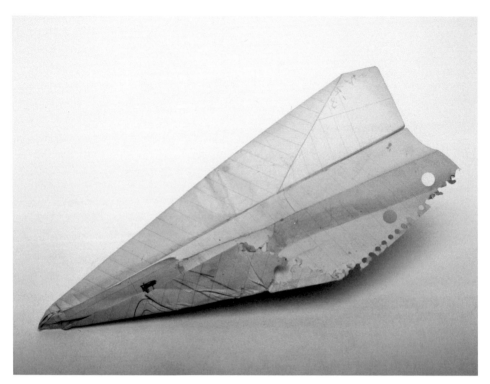

PA206

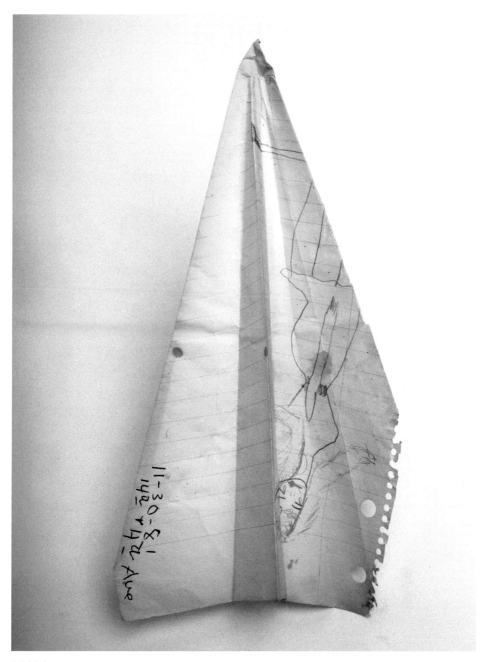

PA206a

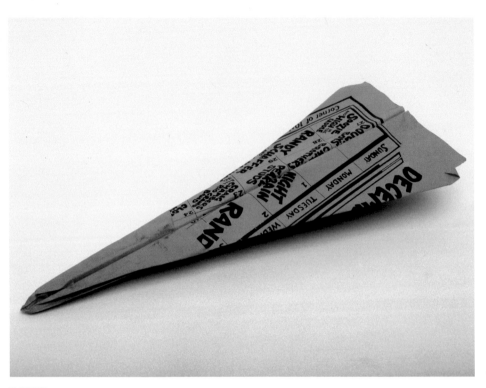

PA207

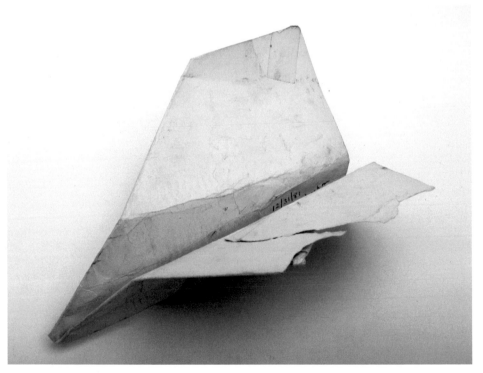

PA208

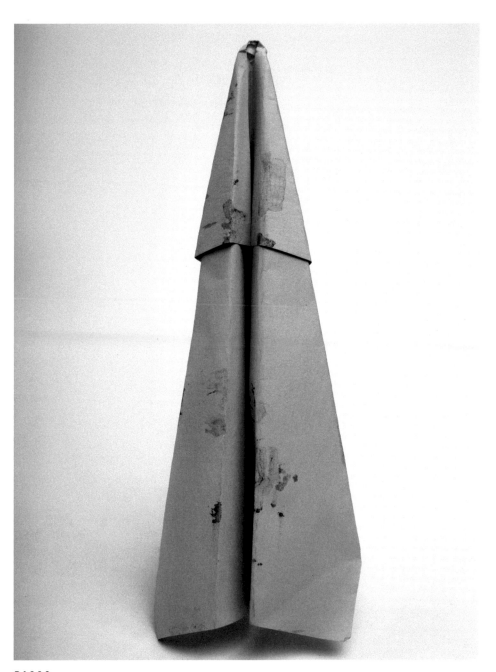

PA209

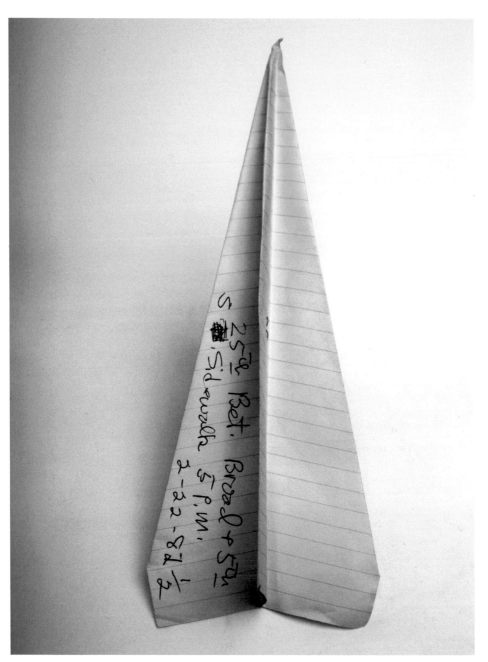

PA210

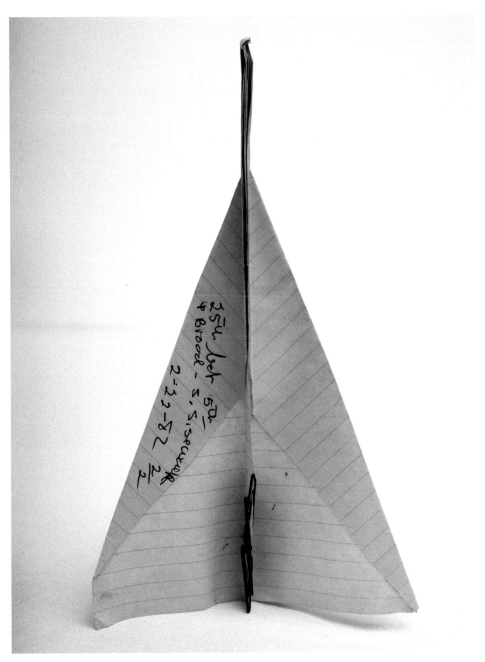

PA211

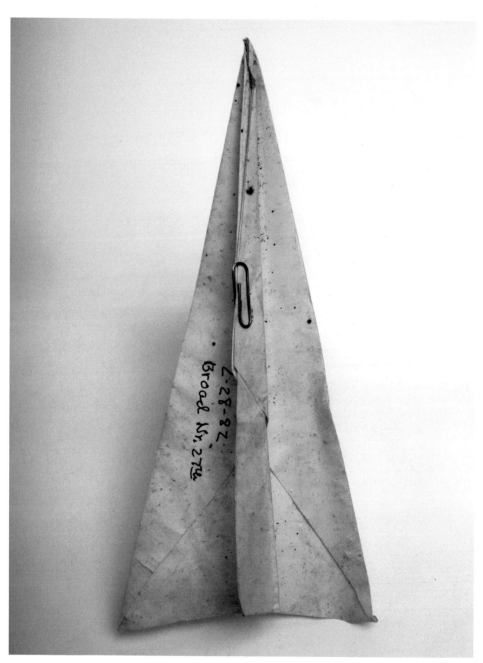

PA212

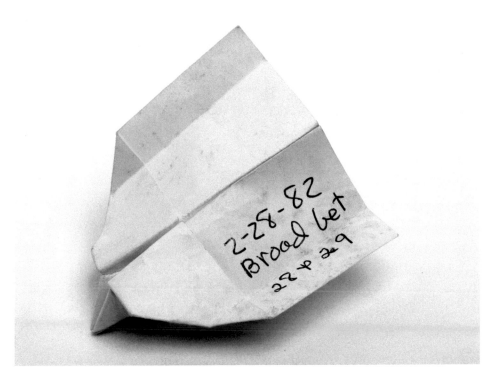

PA213

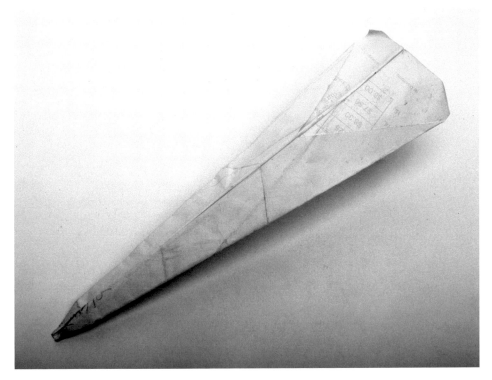

PA214

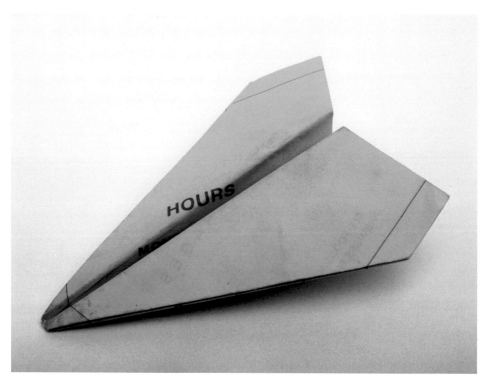

PA215

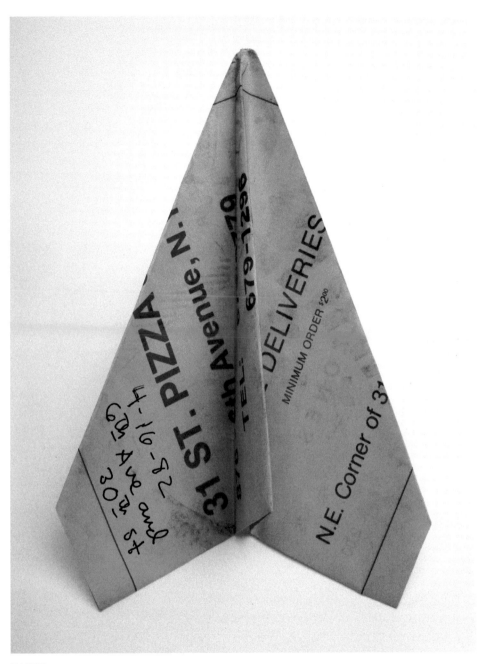

PA215a

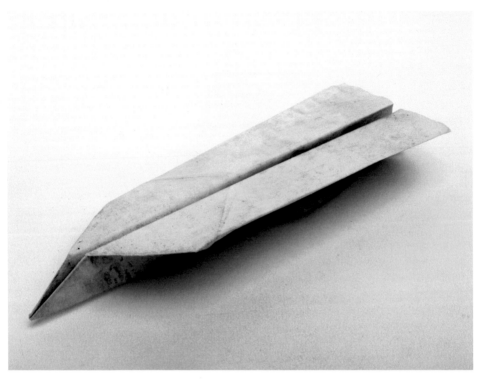

PA216

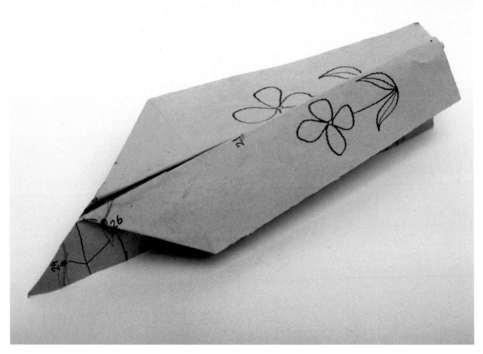

PA217

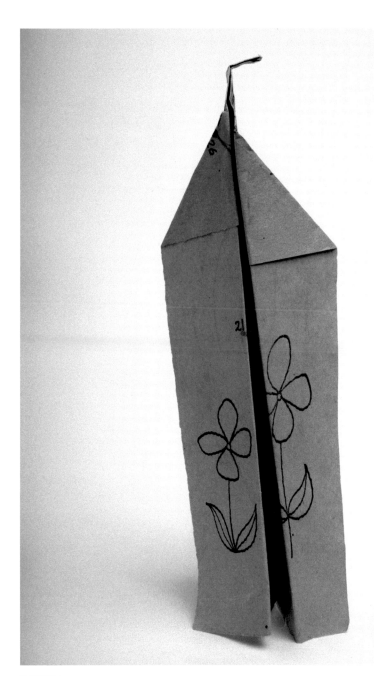

PA217a

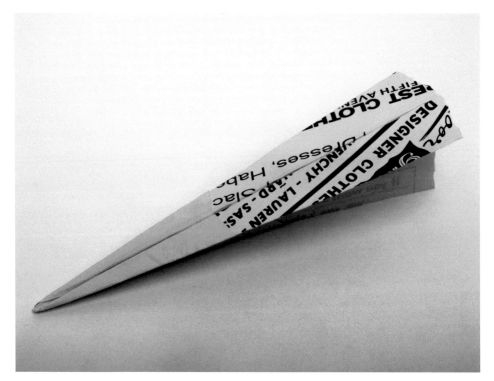

PA218

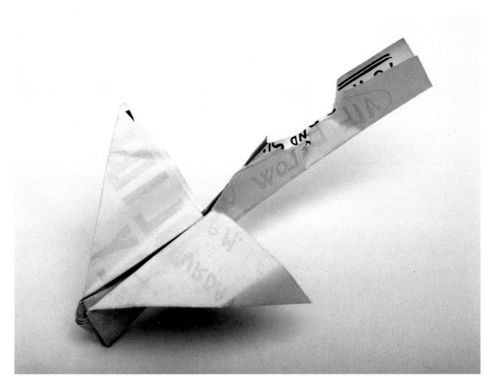

PA219

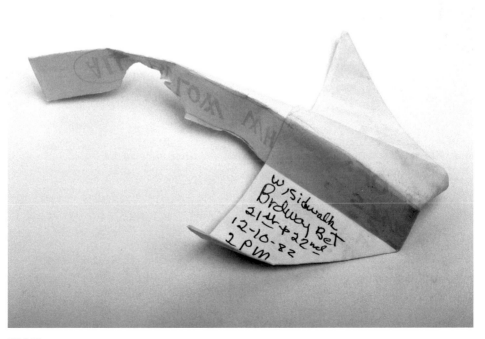

PA219a

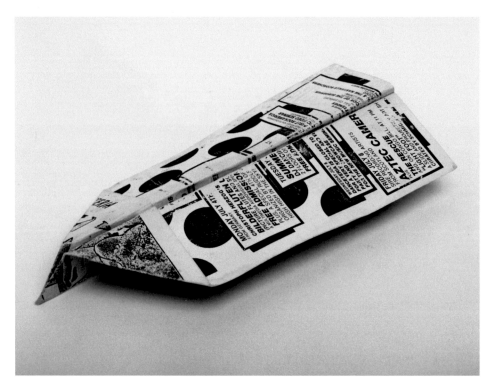

PA220

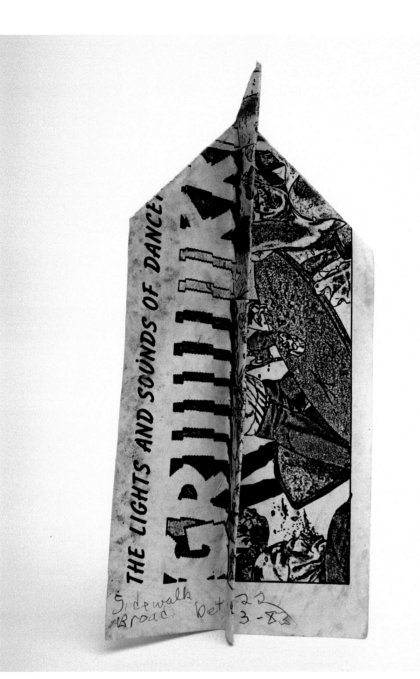

PA220a

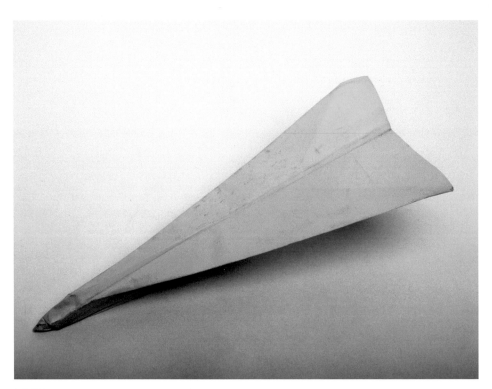

PA221

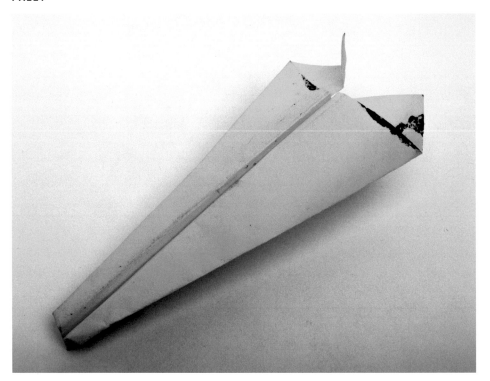

PA222

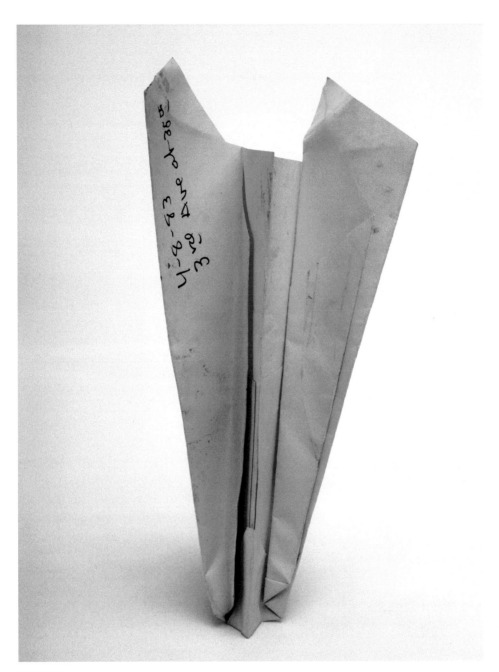

PA222a

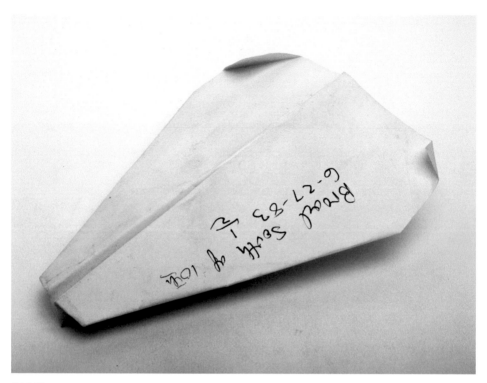

PA223

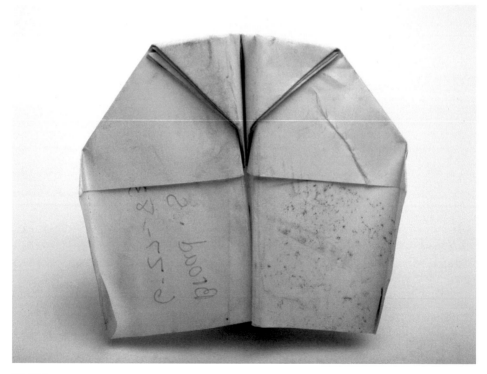

PA224

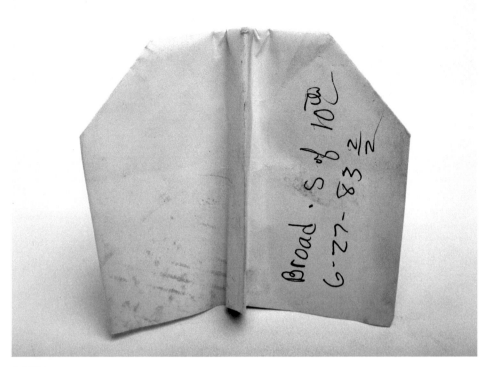

PA224a

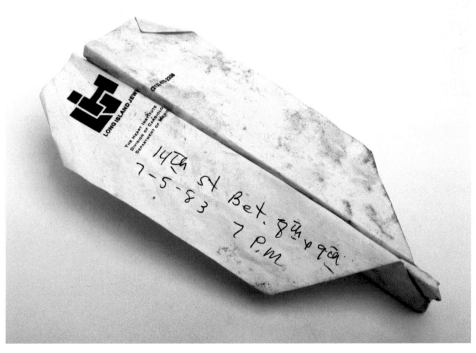

PA225

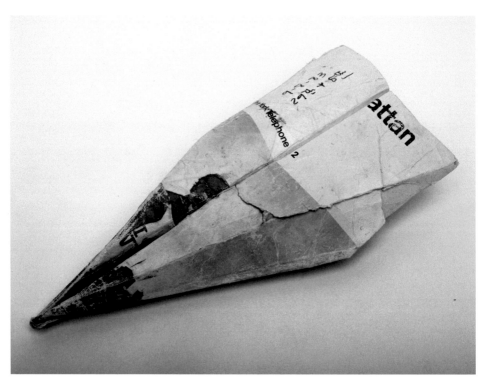

PA226

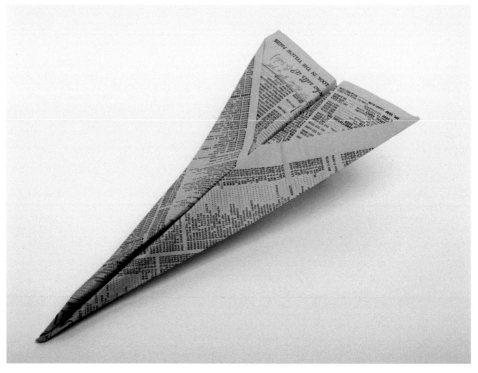

PA227

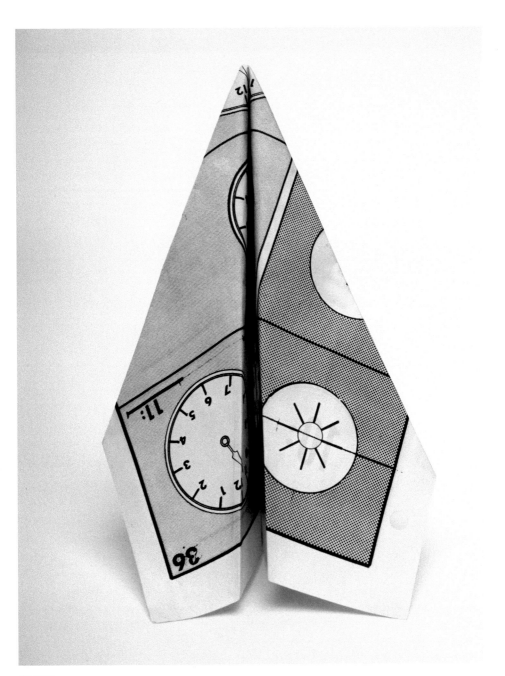

PA228

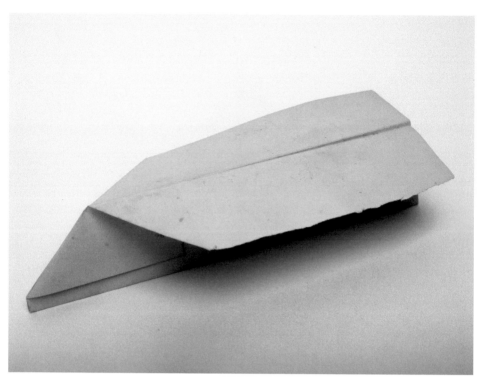

PA229

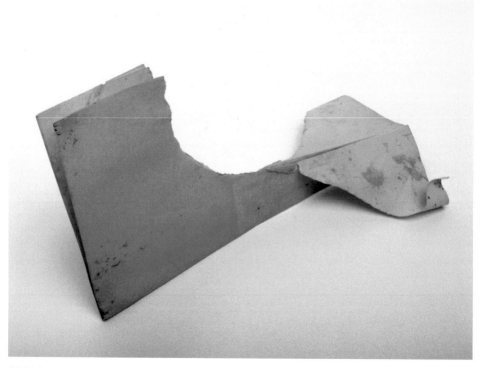

PA230

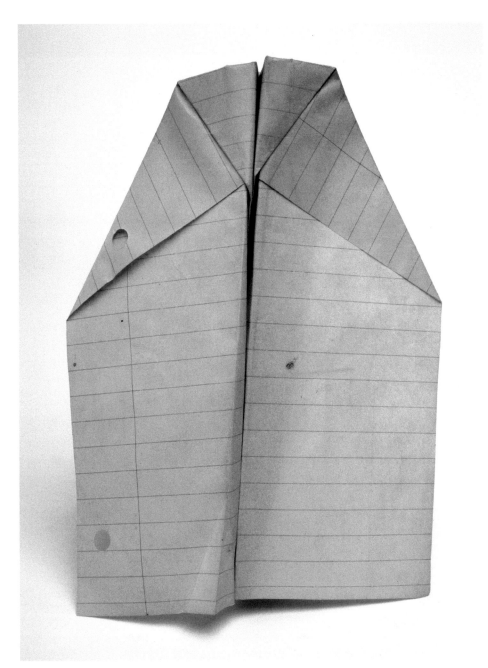

PA231

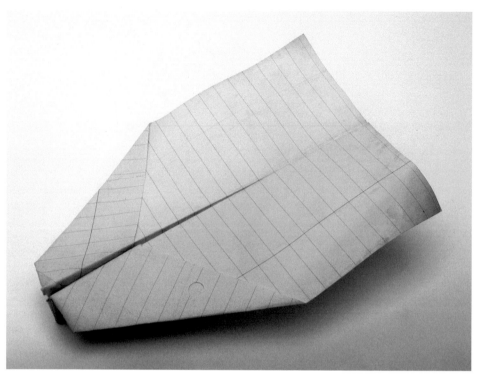

PA232

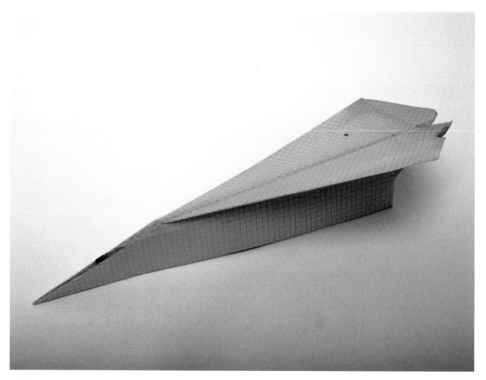

PA233

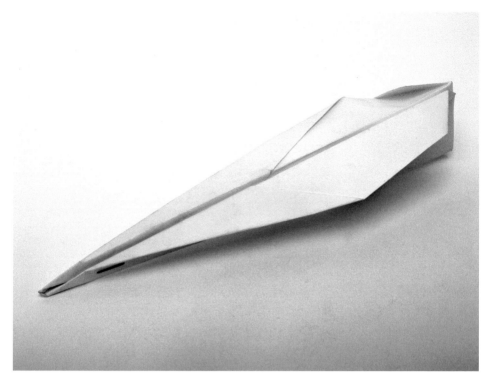

PA234

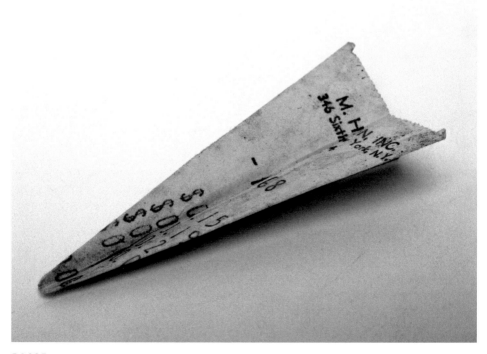

PA235

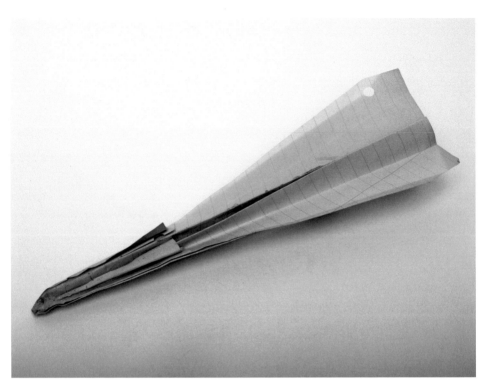

PA236

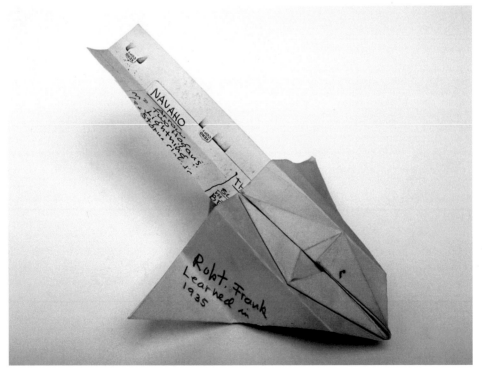

PA237

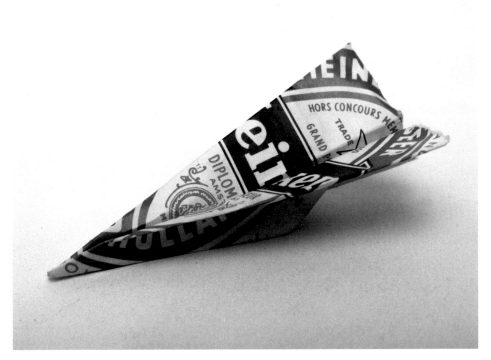

PA238

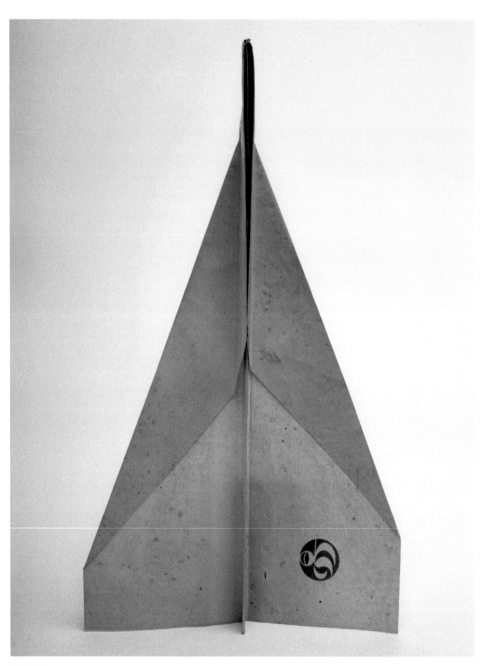

PA239

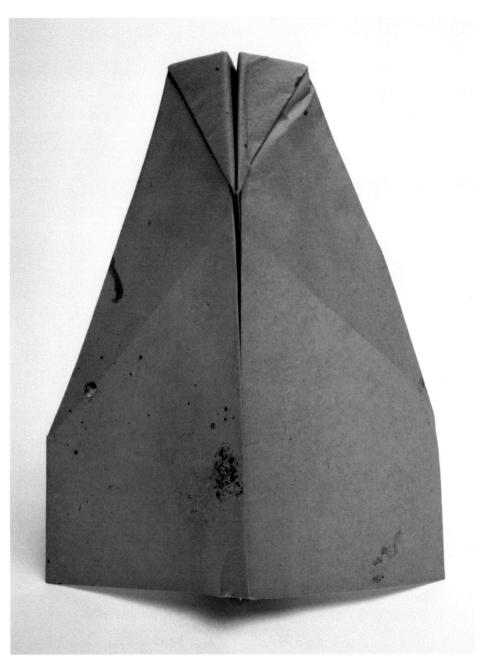

PA240

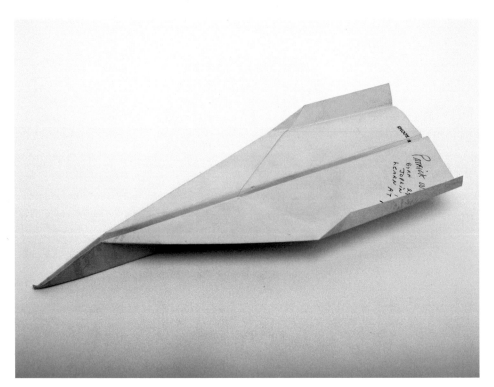

PA241

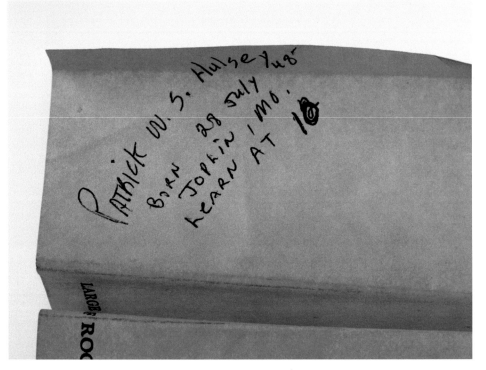

PA241a

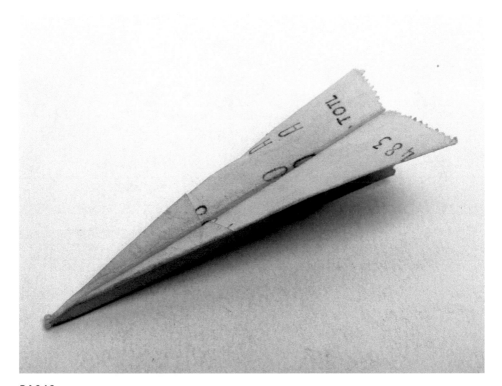

PA242

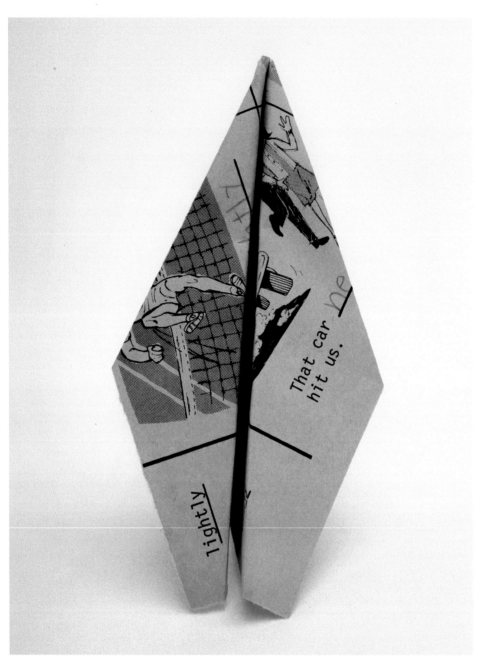

PA243

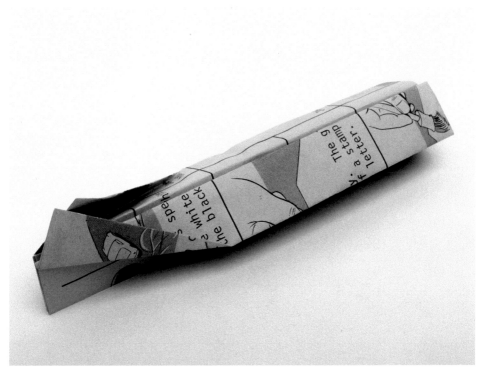

PA244

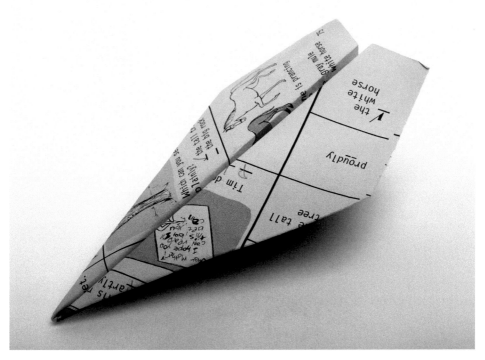

PA245

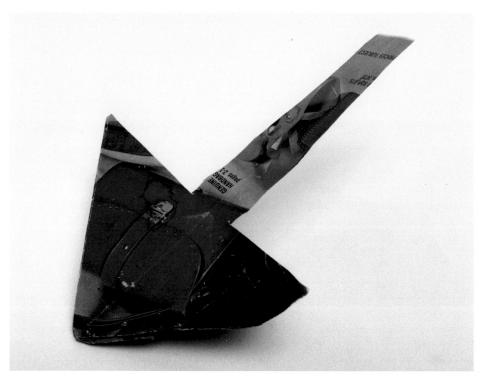

PA246

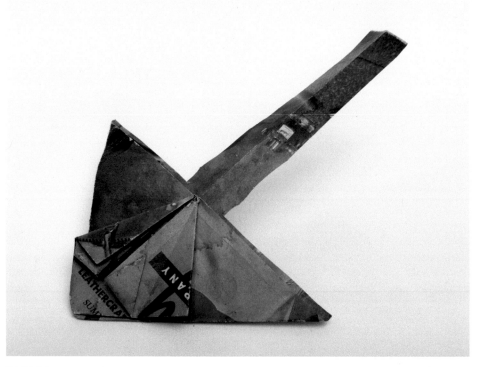

PA246a

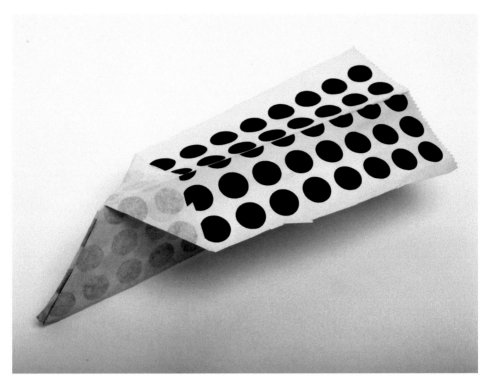

PA247

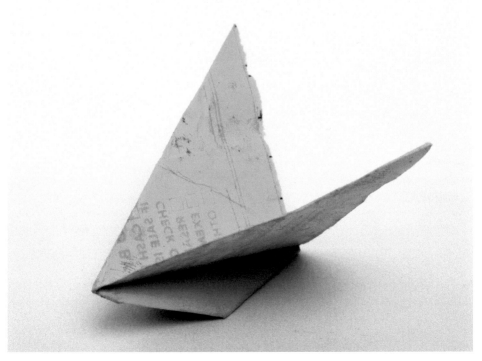

PA248

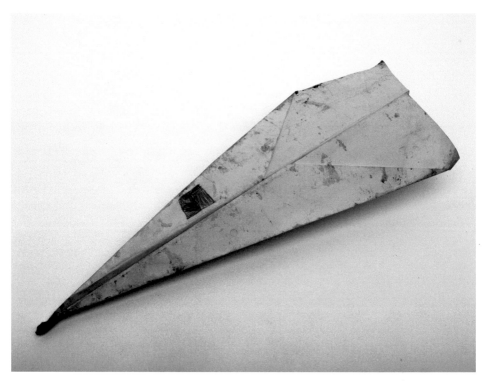

PA249

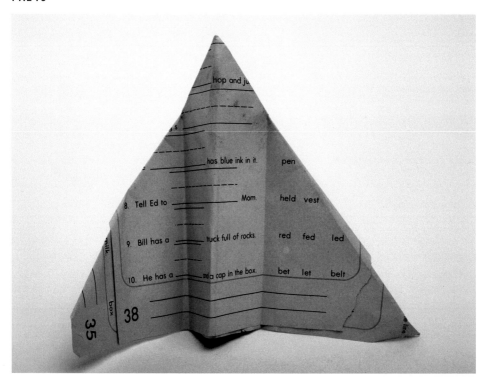

PA250

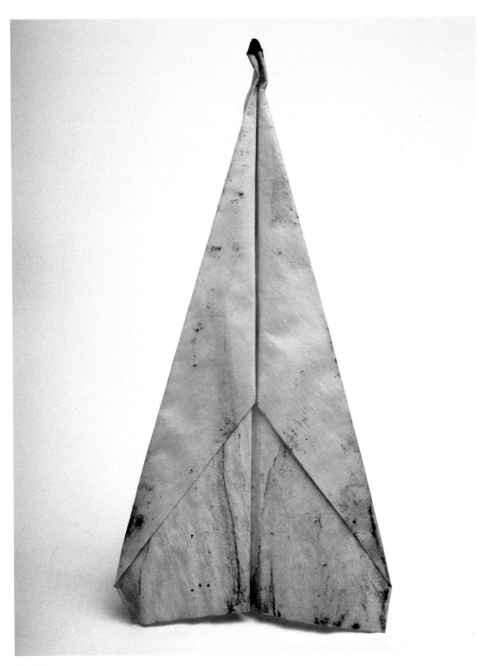

PA251

MAP

The red dots on this map indicate locations where Harry Smith found the individual paper airplanes that he collected in New York City, circa 1961–1983. All locations were identified by referencing annotations written on the planes by Smith.

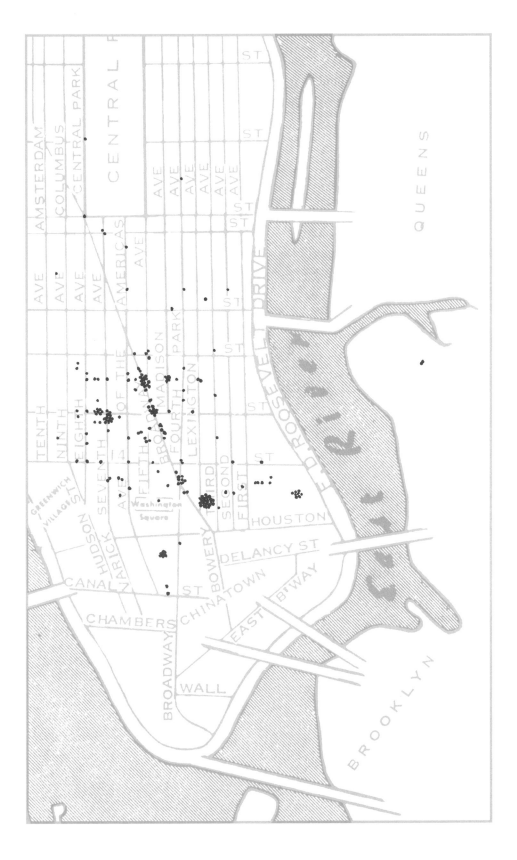

NOTES ON THE PAPER AIRPLANES

PA1: September 20, 1961: West 14th St. between 7th Ave. & 8th Ave.

PA2: May 1964: 6th Ave. & West 18th St.

PA3: June 23, 1966: East 7th St. (north side) between Ave. C & Ave. D

PA4: February 24, 1967: East 41st St. (north side) between Madison Ave. & Vanderbilt Ave. *41st St. does not intersect with Vanderbilt Ave., which runs from 42nd St. to 47th St. in Manhattan.*

PA5: February 25, 1967: West 12th St. (north side) between 5th Ave. & University Pl. *This location is near Smith's residence in the mid-1960s, Hotel Albert at 23 East 10th Street.*

PA6: February 25, 1967: no location noted; "L. J. Ziprin." *This plane is credited to Lionel Ziprin (1924–2009), poet, Kabbalist, and longtime colleague of Smith. Smith did design work for Ziprin's unsuccessful greeting card company, Ink Weed Arts, in the 1950s*

PA7: February 28, 1967: no location noted; "Lance."

PA8: February 28, 1967: no location noted; "Jerry." *This plane is made from Hotel Albert stationery. See note PA5.*

PA9: February 28, 1967: no location noted; "Tom T. C."

PA10: February 28, 1967: no location noted; "Tom T. Standard Paper Airplane A."

PA11: February 28, 1967: no location noted; "Tom T. B."

PA12: February 28, 1967: no location noted; "Jim Dill A."

PA13: February 28, 1967: no location noted; "Jim Dill C."

PA14: March 1967: "Cooper Union C." *The Cooper Union for the Advancement of Science and Art is a college located in the East Village neighborhood of Manhattan. This series (PA14–PA32) is believed to have been made by students in Jonas Mekas' film class.*

PA15: March 1967: "Cooper Union C."

PA16: March 1967: "Cooper Union A."

PA17: March 1967: "Cooper Union C."

PA18: March 1967: "Cooper Union B."

PA19: March 1967: "Cooper Union B."

PA20: March 1967: "Cooper Union."

PA21: March 1967: "Cooper Union."

PA22: March 1967: "Cooper Union."

PA23: March 1967: "Cooper Union."

PA24: March 1967: "Cooper Union."

PA25: March 1967: "Cooper Union."

PA26: March 1967: "Cooper Union."

PA27: March 1967: "Cooper Union."

PA28: March 1967: "Cooper Union."

PA29: March 1967: "Cooper Union."

PA30: March 1967: "Cooper Union."

PA31: March 1967: "Cooper Union."

PA32: March 1967: "Cooper Union."

PA33: March 4, 1967: no location noted; "K. Lee."

PA34: March 4, 1967: no location noted; "Kenneth Lea Learned in Memphis – used until 5th grade – (Lea is now 21)."

PA35: March 4, 1967: 30 Cooper Square; "In grass, S. Side of New Cooper Union Bldg."

PA36: March 4, 1967: no location noted; "Paul Wolf 3rd Grade or Before (21 yrs old now)."

PA37: March 7, 1967: 7th Ave. & West 29th St. (northwest corner)

PA38: March 25, 1967: Ave. A & East 10th St. *This address is near the second location of Peace Eye Bookstore (147 Ave. A), a store run by Ed Sanders of the Fugs, whose debut album was recorded by Smith.*

PA39: March 28, 1967: Broadway & East 10th St. *This location is near the Grace Church School, whose playground is on East 10th St. between Broadway and 4th Ave.*

PA40: March 28, 1967: Broadway & East 10th St. *See note PA39.*

PA41: March 28, 1967: Broadway & East 10th St. *See note PA39.*

PA42: March 30, 1967: 4th Ave. & East 14th St.; "Lex. Subway (Uptown at 14th)."

PA43: April 12, 1967: Mott St. & Pell St.

PA44: April 16, 1967: no location noted.

PA45: April 26, 1967: East 8th St. (north side) between 2nd Ave. & 3rd Ave. *This plane is made from a handbill for a concert by Dave Van Ronk, The Mothers of Invention, and Ian and Sylvia. The show was either held at the Café Au Go Go or at The Infinite Poster, Inc., which shared the same address.*

PA46: April 27, 1967: no location noted; "T. Tadlock." *This plane is on Hotel Albert Stationary. See note PA5.*

PA47: June 14, 1967: 222 West 23rd St.; "Hotel Chelsea Lobby." *This plane was found in the Hotel Chelsea lobby. Smith lived at the hotel at 222 West 23rd St. in Manhattan for a period during the 1960s and 1970s. He spent several months living there again in 1991, and died in room 328.*

PA48: June 23, 1967: East 7th St. (north side) between Ave. C & Ave. D

PA49: June 23, 1967: East 7th St. (north side) between Ave. C & Ave. D

PA50: June 23, 1967: East 7th St. (north side) between Ave. C & Ave. D

PA51: June 23, 1967: East 7th St. (north side) between Ave. C & Ave. D

PA52: June 23, 1967: East 7th St. (north side) between Ave. C & Ave. D

PA53: June 23, 1967: East 7th St. (north side) between Ave. C & Ave. D

PA54: June 23, 1967: East 7th St. (north side) between Ave. C & Ave. D

PA55: September 6, 1967: West 21st St. (south side) between 7th Ave. & 8th Ave.

PA56: September 6, 1967: West 21st St. (south side) between 7th Ave. & 8th Ave.

PA57: September 25, 1967: East 9th St. & University Place.

PA58: September 28, 1967: West 22nd St. between 8th Ave. & 9th Ave. *This address is one block away from the Hotel Chelsea. See note PA47.*

PA59: September 31, 1967: 7th Ave. (west side) between West 19th St. & West 20th St. *Noted date does not exist.*

PA60: October 3, 1967: East 10th St. (south side) between Ave. A & 1st Ave. *See note for PA38.*

PA61: October 3, 1967: East 9th St. (south side) between 1st Ave. & 2nd Ave. *See note for PA38.*

PA62: October 3, 1967: East 10th St. between Ave. A & Ave. B. *See note for PA38.*

PA63: October 7, 1967: 7th Ave. & West 21st St. (southwest corner).

PA64: October 22, 1967: West 23rd St. (south side) between 7th Ave. & 8th Ave. *This is the same block as the Hotel Chelsea. See note PA47.*

PA65: October 22, 1967: West 23rd St. (south side) between 7th & 8th Ave. *See note PA64.*

PA66: October 24, 1967: West 23rd St. (south side) between 7th & 8th Ave. *See note PA64.*

PA67: November 14, 1967: West 79th St. (north side) between Columbus Ave. & Amsterdam Ave.

PA68: November 27, 1967: Washington Square.

PA69: December 24, 1967: 7th Ave. (west side) between West 20th St. &

West 21st St. *This location is near P.S. 11 elementary school located at 320 West 21st St.*

PA70: December 25, 1967: 7th Ave. between West 21st St. & West 22nd St. *See note PA69.*

PA71: December 25, 1967: 7th Ave. (west side) between West 21st St. & West 22nd St. *See note PA69.*

PA72: December 25, 1967: 7th Ave. (west side) between West 21st St. & West 22nd St. *See note PA69.*

PA73: December 25, 1967: 7th Ave. (west side) between West 21st St. & West 22nd St. *See note PA69.*

PA74: December 25, 1967: 7th Ave. (west side) between West 21st St. & West 22nd St. *See note PA69.*

PA75: December 25, 1967: 7th Ave. (west side) between West 21st St. & West 22nd St. *See note PA69.*

PA76: December 25, 1967: 7th Ave. (west side) between West 21st St. & West 22nd St. *See note PA69.*

PA77: December 25, 1967: 7th Ave. (west side) between West 21st St. & West 22nd St. *See note PA69.*

PA78: December 25, 1967: 7th Ave. (west side) between West 21st St. & West 22nd St. *See note PA69.*

PA79: January 20, 1968: 5th Ave. (west side) between West 34th St. & West 35th St. *This location is below the Empire State building.*

PA80: January 26, 1968: West 32nd St. (south side) between 8th Ave. & 9th Ave.

PA81: January 31, 1968: 222 West 23rd Street; "Chelsea Lobby" *This plane is from the Hotel Chelsea lobby. See note PA47.*

PA82: February 1, 1968: no location noted; "Van Felix."

PA83: February 1, 1968: no location noted; "Van Felix."

PA84: February 1, 1968: 116 West 11th St.; "Andrew David Van Felix 8 years 18 1/3 P.S. 41 (Greenwich Ave.)" *Smith notes elementary school P.S. 41 located on 11th St. near Greenwich Ave.*

PA85: February 7, 1968: West 31st St. (south side) between 8th Ave. & 9th Ave.

PA86: September 19, 1968: 30 Cooper Square; "S. of Cooper Union."

PA87: May 1969: 7th Ave. & West 23rd St. *See note PA64.*

PA88: June 16, 1969: West 22nd St. between 6th Ave. & 7th Ave.

PA89: January 25, 1970: 6th Ave. & West 54th St.

PA90: August 10, 1976: Madison Ave. & East 23rd St.; "2am."

PA91: August 15, 1976: 8th Ave. & West 23rd St. *See note PA64.*

PA92: August 16, 1976: 222 West 23rd St.; "Chelsea Hotel Lobby (made by girl in)." *This plane is from the Hotel Chelsea lobby. See note PA47.*

PA93: August 17, 1976: Greenwich Ave. & West 11th St.; "3:00 T.S.U." *Annotation is difficult to read. This is an assumed location.*

PA94: August 28, 1976: no location noted.

PA95: August 28, 1976: St. Mark's Pl. & 2nd Ave.

PA96: September 7, 1976: 8th Ave. & West 19th St.

PA97: September 7, 1976: 8th Ave. & West 17th St.

PA98: September 7, 1976: Greenwich Ave. near West 14th St.

PA99: September 7, 1976: East 14th St. & 1st Ave.

PA100: September 13, 1976: Broadway & East 8th St.

PA101: September 21, 1976: 218 West 23rd St.; "11P.M." *See note PA64.*

PA102: September 24, 1976: Broadway & West 34th St. *See note PA79.*

PA103: September 27, 1976: no location noted.

PA104: October 14, 1976: 6th Ave. &

West 59th St.; "6 & CPS." *CPS is likely referring to Central Park South, which would be West 59th St. in Manhattan.*

PA105: October 14, 1976: 6th Ave. & West 59th St.; "6 & CPS." *See note PA104.*

PA106: October 15, 1976: 7th Ave. & West 57th St.

PA107: October 15, 1976: 7th Ave. & West 57th St.

PA108: October 15, 1976: Central Park West & West 73rd St.

PA109: October 29, 1976: 5th Ave. & West 4th St. *4th St. does not intersect with 5th Ave., which begins at Washington Square North in Manhattan.*

PA110: October 30, 1976: 7th Ave. & West 23rd St.

PA111: October 31, 1976: 6th Ave. & West 8th St.

PA112: November 1, 1976: no location noted.

PA113: April 15, 1977: East 23rd St. between Park Ave. South & Lexington Ave.

PA114: August 1977: no location noted.

PA115: October 2, 1977: 20 West 29th St.; "Breslin." *Smith left the Hotel Chelsea circa 1975 and moved into the Hotel Breslin located at the corner of Broadway and West 29th Street. Today, that location houses the Ace Hotel, and the lobby features Allen Ginsberg's portrait of Smith "transforming milk into milk," shot in the Breslin in 1985.*

PA116: October 5, 1977: 5th Ave. & West 20th St.

PA117: October 29, 1977: Lexington Ave. & East 29th St. *This location is near the Hotel Breslin. See note PA115.*

PA118: October 29, 1977: Lexington Ave. & East 29th St. *See note PA117.*

PA119: October 30, 1977: 5th Ave. & West 34th St. *See note PA79.*

PA120: October 30, 1977: 5th Ave. & West 33rd St. *See note PA79.*

PA121: October 30, 1977: 6th Ave. & West 42nd St.

PA122: November 1977: Broadway & East 8th St.; "11:00pm."

PA123: February 10, 1978: Broadway & West 59th Street.

PA124: March 6, 1978: West 29th St. between 7th Ave. & 8th Ave.

PA125: March 20, 1978: 2nd Ave. & East 46th St.

PA126: March 31, 1978: Spring St. & Wooster St. *This location is near the second location of Anthology Film Archives at 80 Wooster Street. Smith consistently misidentifies Wooster as "Woocester."*

PA127: July 8, 1978: Broadway & East 23rd St.

PA128: mid-July 1978: no location noted.

PA129: August 10, 1978: 213 Park Ave.; "Maxes K.C." *This plane is made out of a menu from Max's Kansas City, a nightclub that served as a convergence point for members of Andy Warhol's entourage and the downtown art and music scenes.*

PA130: August 16, 1978: West 29th St. between Broadway & 6th Ave. *See note PA117.*

PA131: September 6, 1978: 5th Ave. between West 17th St. & West 18th St.

PA132: September 12, 1978: East 29th St. between Park Ave. & Madison Ave. *See note PA117.*

PA133: September 21, 1978: East 29th St. (south side) & Madison Ave.; "3:00P.M." *See note PA117.*

PA134: September 21, 1978: East 29th St. (south side) & Madison Ave.; "8:00P.M." *See note PA117.*

PA135: September 23, 1978: East 29th St. (south side) & Madison Ave. *See note PA117.*

PA136: October 19, 1978: 8th Ave. & West 30th St.

PA137: January 2, 1979: West 25th St. between 7th Ave. & 8th Ave.

PA138: March 17, 1979: West 28th St. between 5th Ave. & Broadway; "sidewalk." *See note PA117.*

PA139: April 5, 1979: Prince St. & Wooster St.; "fair, windy." *See note PA126. This represents an odd instance of Smith annotating the weather conditions on the day that he found this plane.*

PA140: April 5, 1979: Prince St. & Wooster St. *See note PA126.*

PA141: April 5, 1979: Prince St. & Wooster St. *See note PA126.*

PA142: April 16, 1979: Park Ave. & East 65th St.

PA143: April 24, 1979: West 49th St. between 9th Ave. & 10th Ave.; "In Playground."

PA144: May 31, 1979: West 29th St. between 7th Ave. & 8th Ave.

PA145: September 19, 1979: Madison Ave. & East 29th St. *See note PA117.*

PA146: September 20, 1979: Madison Ave. & East 29th St. *See note PA117.*

PA147: September 20, 1979: Park Ave. South & East 27th St. *See note PA117.*

PA148: September 20, 1979: Madison Ave. & East 29th St. *See note PA117.*

PA149: October 21, 1979: Broadway & Prince St.

PA150: 1979: no location noted.

PA151: 1979: no location noted.

PA152: 1979: no location noted.

PA153: April 2, 1980: 5th Ave. & West 28th St. *See note PA117.*

PA154: April 3, 1980: Prince St. & Wooster St. *See note PA126.*

PA155: June 21, 1980: 7th Ave. & West 11th St.

PA156: July 2, 1980: Broadway & East 19th St.

PA157: July 3, 1980: Broadway & West 31st St. *See note PA117.*

PA158: July 15, 1980: East 31st St. (west side) & Park Ave. South.

PA159: July 16, 1980: 3rd Ave. & East 26th St.

PA160: July 25, 1980: Broadway & West 29th St. *See note PA117.*

PA161: July 31, 1980: Spring St. & Wooster St. *See note PA126.*

PA162: August 1, 1980: 3rd Ave. & East 18th St.

PA163: August 14, 1980: Broadway & West 29th St. *See note PA117.*

PA164: August 14, 1980: Broadway & West 29th St. *See note PA117.*

PA165: August 14, 1980: Broadway & West 29th St. *See note PA117.*

PA166: August 14, 1980: Broadway & East 23rd St.

PA167: August 14, 1980: Broadway & East 23rd St.

PA168: August 14, 1980: Broadway & East 23rd St.

PA169: August 14, 1980: Broadway & East 23rd St.

PA170: August 14, 1980: Broadway & East 23rd St.

PA171: August 27, 1980: Park Ave. South & East 25th St.

PA172: August 27, 1980: Broadway & East 11th St. *This is near the Strand Book Store, which was one of Smith's regular haunts.*

PA173: August 27, 1980: Broadway & East 11th St. *See note PA172.*

PA174: September 2, 1980: Prince St. & Wooster St. *See note PA126.*

PA175: September 2, 1980: Canal St. & Wooster St. *See note PA126.*

PA176: September 3, 1980: Broadway & East 18th St.

PA177: September 3, 1980: Broadway & East 23rd St.

PA178: September 15, 1980: Grand St. & Wooster St. *See note PA126.*

PA179: September 18, 1980: Union Square West & East 14th St.

PA180: September 19, 1980: 5th Ave. & West 18th St.

PA181: September 20, 1980: Broadway & East 23rd St.

PA182: September 20, 1980: Broadway & East 23rd St.

PA183: October 5, 1980: Broadway & East 12th St. *See note PA172.*

PA184: October 5, 1980: 6th Ave. & West 14th St.

PA185: October 16, 1980: East 14th St. between 1st Ave. & 2nd Ave.

PA186: October 29, 1980: Broadway & East 23rd St.

PA187: October 30, 1980: no location noted; "Rm 714 Scott Feero." *This plane is credited to Scott Feero, who took photographs of Smith.*

PA188: November 14, 1980: Broadway & West 29th St. *See note PA117.*

PA189: November 16, 1980: Broadway & West 29th St. *See note PA117.*

PA190: November 30, 1980: 5th Ave. & West 24th St.

PA191: December 1, 1980: Broadway & West 24th St.

PA192: December 6, 1980: Broadway & West 28th St. *See note PA117.*

PA193: December 6, 1980: Broadway & West 28th St. *See note PA117.*

PA194: December 15, 1980: location annotation is illegible.

PA195: April 11, 1981: Madison Ave. & East 16th St. *16th St. does not intersect with Madison Ave., which begins at 23rd St. in Manhattan.*

PA196: April 20, 1981: 6th Ave (mid-block, east side) & West 46th St.

PA197: April 22, 1981: Broadway between West 29th St. & West 30th St. *See note PA117.*

PA198: May 1, 1981: Broadway between East 19th St. & East 20th St.

PA199: May 7, 1981: West 19th St. between 5th Ave. & 6th Ave.

PA200: May 7, 1981: West 19th St. (north side) between 5th Ave. & 6th Ave.

PA201: May 10, 1981: 5th Ave. & West 28th St. (southeast corner).

PA202: June 24, 1981: West 27th St. between Broadway & 6th Ave.; "11:30pm."

PA203: July 17, 1981: East 44th St. (north side) between 3rd Ave. & Lexington Ave.

PA204: September 13, 1981: Grand St. & Graham Ave., Brooklyn.

PA205: November 27, 1981: 4th Ave. (west side) between 11th St. & 12 St.; "sidewalk." *See note PA172.*

PA206: November 30, 1981: 4th Ave. & East 14th St.

PA207: December 6, 1981: West 10th St. & Waverly Pl.

PA208: December 31, 1981: Bushwick Ave. & Grand St., Brooklyn.

PA209: February 1, 1982: West 18th St. between 9th Ave. & 10th Ave. *This location was near the Charles Evan Hughes High School located on 18th St. between 8th Ave. and 9th Ave. Today it is called the High School for the Humanities.*

PA210: February 22, 1982: West 25th St. (south sidewalk) between 5th Ave. & Broadway; "5pm."

PA211: February 22, 1982: West 25th St. (south sidewalk) between 5th Ave. & Broadway.

PA212: February 28, 1982: Broadway & West 27th St. *See note PA117.*

PA213: February 28, 1982: Broadway between West 28th St. & West 29th St. *See note PA117.*

PA214: March 11, 1982: East 10th St. between Ave. A & 1st Ave.

PA215: April 16, 1982: 6th Ave. & 30th St. *See note PA117.*

PA216: May 13, 1982: Broadway between East 30th St. & East 31st St. *See note PA117.*

PA217: May 15, 1982: Ave. B between East 10th St. & East 11th St.; "Scott."

PA218: September 17, 1982: Broadway

(east sidewalk) between East 20th St. & East 21st St.

PA219: December 10, 1982: Broadway (west sidewalk) between East 21st St. & East 22nd St.; "2pm."

PA220: March 1983: Broadway between East 21st St. & East 22nd St.; "sidewalk." *Cross street annotation cannot be confirmed, this is an assumed location. This plane is made from a handbill for Danceteria, a nightclub that was located at 30 West 21st St.*

PA221: April 8, 1983: 3rd Ave. & East 35th St.

PA222: April 8, 1983: 3rd Ave. & East 35th St.

PA223: June 27, 1983: Broadway (south side) & East 10th St. *See note PA39.*

PA224: June 27, 1983: Broadway (south side) & East 10th St. *See note PA39.*

PA225: July 5, 1983: West 14th St. between 8th Ave. & 9th Ave.; "7 p.m."

PA226: September 8, 1983: 8th Ave. & West 29th St. *See note PA117.*

PA227: undated: West 23rd St. (south side) between 8th Ave. & 9th Ave.

PA228: no annotation.

PA229: undated: no location noted; "Primitive Plane Howard (A16) Do Not Remember."

PA230: no annotation.

PA231: no annotation.

PA232: no annotation.

PA233: no annotation.

PA234: no annotation.

PA235: no annotation.

PA236: no annotation.

PA237: undated: no location noted; "Robt. Frank Learned in 1935." *This plane is credited to photographer Robert Frank, who does not remember making it for Smith. The plane is made from a photocopy of Smith's string figure notes.*

PA238: no annotation.

PA239: no annotation.

PA240: no annotation.

PA241: undated: no location noted; "Patrick W.S. Hulsey Born 28 July 48 – Joplin, MO. Learn at 10." *Patrick Hulsey was Smith's assistant and camera operator for* Film Number 18: Mahagonny *(1970–80).*

PA242: no annotation.

PA243: no annotation.

PA244: no annotation.

PA245: no annotation.

PA246: no annotation.

PA247: no annotation.

PA248: no annotation.

PA249: no annotation.

PA250: no annotation.

PA251: no annotation.

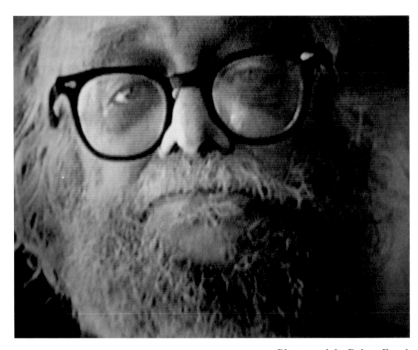

Photograph by Robert Frank

HARRY SMITH BIOGRAPHY

Purposefully elusive, Harry Everett Smith (1923–1991)—a note-worthy and notorious filmmaker, painter, anthropologist, musi-cologist, and occultist—on occasion claimed to be both the lost child of British occultist Aleister Crowley or the son of Grand Duchess Anastasia Nikolaevna of Russia. In fact, Smith was born in Portland, Oregon, in 1923, to a Pacific American Fisheries employee and a teacher who were practicing Theosophists. Fascinated with anthropology as a youth, by age 15 Smith had started to document, transcribe, and record the dialects and rituals of local Pacific Northwest Native American populations. After high school, he studied anthropology for five semesters at the University of Washington.

Smith relocated to the San Francisco Bay Area in 1945, where he quickly became a distinctive figure within the burgeoning bohe-mian art and music communities. He spent much of his time during this period drawing, painting, collecting records, and regularly attending Frank Stauffacher's pioneering Art in Cinema screen-ings at the San Francisco Museum of Modern Art. Through his organizational involvement with that series, he forged instrumental relationships with groundbreaking filmmakers including Jordan Belson, Oskar Fischinger, Hy Hirsh, and James and John Whitney. It is in Northern California that Smith produced his earliest avant-garde animations, most of which would later be assembled into his remarkable compilation *Early Abstractions*, which includes the shorts *Film Numbers 1–5, 7*, and *10* (1946–57).

With a grant arranged by the influential Museum of Non-Objective Painting director Hilla Rebay, Smith moved to New York City in 1951. There he met Moe Asch, founder of Folkways Records, who encouraged him to channel his penchant for collecting rare pre-World War II 78rpm discs into what became the widely celebrated *Anthology of American Folk Music* (1952). Throughout the 1950s, Smith continued working on his art and experimental animations in relative obscurity. A chance encounter with poet Allen Ginsberg at the Five Spot Café jazz club during a Thelonious Monk concert in 1960 resulted in Smith's introduction to New York's poetry, art,

and underground film scenes. Never one to settle down, Smith spent most of the next few decades living in a series of cramped rooms at the Hotel Albert, Hotel Chelsea, and the Hotel Breslin.

In the 1960s, Smith completed the majority of his most renowned films including the meticulously collaged cut-out animation, *Film Number 12: Heaven and Earth Magic Feature* (1957–62); a layered-image diary film titled *Film Number 14: Late Superimpositions* (1964); and his incomplete mystical adaptation of *The Wonderful Wizard of Oz, Film Number 16: Oz, The Tin Woodsman's Dream* (circa 1967). His interests in anthropology and field recording never abated, and during a chaotic 1964 trip to Oklahoma, Smith documented Kiowa Native American peyote rituals that were later issued by Folkways Records as the three-LP box set, *The Kiowa Peyote Meeting* (1973).

Throughout the 1970s, Smith shot, edited, and raised funds for his longest film, the two-and-a-half-hour multi-screen epic *Film Number 18: Mahagonny* (1970–80). Set to the entirety of Kurt Weill and Bertlot Brecht's German language opera *Aufstieg und Fall der Stadt Mahagonny (Rise and Fall of the City of Mahagonny)*, the film was an elaborately constructed four-projector film performance organized around esoteric principles. A herculean undertaking, the work screened only six times at Manhattan's Anthology Film Archives in 1980. Smith spent the rest of the 1980s completing a few more films and maintaining his various collections of curious items including paper airplanes, decorated Ukrainian eggs, Seminole textiles, and tarot cards. He also continued to make unconventional field recordings of New York City street life. A lifelong occultist, Smith was ordained a gnostic bishop in the Ordo Templi Orientis' Ecclesia Gnostica Catholica in 1986. During his late years, from 1988 to 1991, Smith served as "Shaman-In-Residence" at the Jack Kerouac School of Disembodied Poetics at the Naropa Institute in Boulder, Colorado, where he taught classes on such topics as alchemy and Native American cosmographies.

In 1991, Smith was presented the Chairman's Merit Award for Lifetime Achievement at the Grammys for his "ongoing insight into the relationship between artistry and society, and his deep commitment to presenting folk music as a vehicle for social change." The award was bestowed on him 49 years after the release of the

Anthology and just months before his death at age 68 at the Hotel Chelsea.

Today, Smith's surviving films, art, writings, and possessions are held in private collections and various institutions including Anthology Film Archives in New York; the Smithsonian Center for Folklife and Cultural Heritage in Washington, D.C.; and the Getty Research Institute in Los Angeles.